with compliments

# DESIGNERS' STATIONERY

how designers and design companies
present themselves to the world

# DESIGNERS' STATIONERY

DESIGNERS' STATIONERY

First published in 2001 by:
HBI, an imprint of HarperCollins Publishers
10 East 53rd Street
New York, NY 10022-5299
United States of America

Distributed to the trade and art markets
in the U.S. by:
North Light Books,
an imprint of F&W Publications, Inc.
1507 Dana Avenue
Cincinnati, OH 45207
Tel: (800) 289-0963

Distributed throughout the rest
of the world by:
HarperCollins International
10 East 53rd Street
New York, NY 10022-5299
Fax: (212) 207-7654

ISBN 0-06-621390-8

Conceived, created, and designed by:
Duncan Baird Publishers
6th Floor, Castle House
75–76 Wells Street, London W1T 3QH

Designer: Lloyd Tilbury at Cobalt id
Editor: Marek Walisiewicz at Cobalt id
Project Co-ordinators: Kelly Cody and Tamsin Wilson

10 9 8 7 6 5 4 3 2 1

Typeset in RotisSansSerif
Color reproduction by Colourscan, Singapore
Manufactured in China by Imago

# CONTENTS

Despite the ever-increasing use of electronic communication, there is still something very special about receiving a letter.

With none of the spontaneity of a phone call, none of the convenience of email, and none of the speedy urgency of a fax, the letter would appear to be an anachronism. But perhaps it is for these precise reasons that the letter persists. Compared to the electronic media, a letter is slow and deliberate; it has both presence and permanence; it is able to reflect the personality and status of the sender, not just through its content but in every aspect of its presentation.

Letterheads and stationery are key components of any company's visual identity and often they are the first tangible point of contact between an organization and its clients. When the company's activity is design, stationery assumes a particular importance because it showcases the stylistic approach and taste of the designers involved.

Designers' Stationery comprises some of the very best examples from all over the globe, and it demonstrates how diverse, strange, obscure and beautiful this simple and timeless form of communication can be.

RW

# FOREWORD

# THE WORK

Throughout this book, the work of each studio or designer is laid out on one or two double page spreads. A brief text description lists the items on each spread, beginning at the top left and working round anticlockwise. The majority of items included closely approximate to the standard sizes for printed stationery:

European letterhead: 297 x 210 mm
US letterhead: 216 x 279 mm

Significant departures from these formats or other special production features, such as die cuts and special inks, are noted in the text.

Dear Sir or M

| **Struktur Design** | The Rookery, Halvergate<br>Norfolk NR13 3PN | T: +44 (0)1493 701 766<br>F: +44 (0)1493 701 227 | E: mail@struktur.co.uk<br>W: www.struktur.co.uk |

VAT Registration number 676 1547 10

Sanne, Roger, Tristan, Minnie and Bodoni have moved to:

**The Rookery, Halvergate,**
**Norfolk NR13 3PN**

Telephone: +44 (0)1493 701 766
Facsimile: +44 (0)1493 701 227

# N: 52° 36' 18.5534"
# E: 1° 34' 10.6277"

**Directions:**
From Norwich travelling east take the A47 and bypassing Acle, continue on the A47 towards Great Yarmouth. Opposite the Three Feathers public house, turn right signposted for Halvergate. Crossing over the hump backed bridge follow this road through the marshes into the village of Halvergate. The road bears sharply to the left and after a short distance the drive to The Rookery will be found on the right hand side.

DESIGN COMPANY
**Struktur Design**

DESIGNER
**Roger Fawcett-Tang**

COUNTRY OF ORIGIN
**UK**

DESCRIPTION
Anticlockwise from top left:
Letterhead
Moving cards (front and reverse,
two variants)

# national grid:

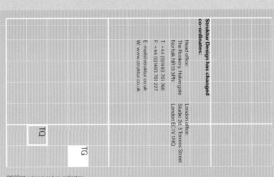

**Struktur Design has changed**
**co-ordinates:**

Head office:
The Rookery, Halvergate,
Norfolk NR13 3PN

London office:
Studio 2d, 5 Torrens Street
London EC1V 1NQ

T: +44 (0)1493 701 766
F: +44 (0)1493 701 227
E: mail@struktur.co.uk
W: www.struktur.co.uk

OSGB36 national grid co-ordinates:

# TG418068

k not c. no e

**Struktur Design**   Studio 2d, 5 Torrens Street   T: +44 (0)20 7833 5626
London EC1V 1NQ   F: +44 (0)20 7833 5636

**Roger Fawcett-Tang**   M: +44 (0)7802 88 54 77   E: roger@struktur.co.uk
www.struktur.co.uk

systematik:

**Struktur Design**   The Rookery, Halvergate   T: +44 (0)1493 701 766
Norfolk NR13 3PN   F: +44 (0)1493 701 227

**Visual engineer**   E: mail@struktur.co.uk
www.struktur.co.uk

zip disk   **Struktur Design**   5 Torrens Street   T: +44 (0)171 833 5626
London EC1V 1NQ   F: +44 (0)171 833 5636

Struktur Design

zip-100

return it

DESIGN COMPANY
**Struktur Design**

DESIGNER
**Roger Fawcett-Tang**

COUNTRY OF ORIGIN
**UK**

DESCRIPTION
**Anticlockwise from top left:
Business cards (front and
reverse)
Insert for Zip disk case
(front and reverse)
Compliments slips (two
variants)**

**Struktur Design** | Head office: | London office: | T: +44 (0)1493 701 766 | E: mail@struktur.co.uk
 | The Rookery, Halvergate | Studio 2d, 5 Torrens Street | F: +44 (0)1493 701 227 | W: www.struktur.co.uk
 | Norfolk NR13 3PN | London EC1V 1NQ | |

kompliments

**Struktur Design** | The Rookery, Halvergate | T: +44 (0)1493 701 766 | E: mail@struktur.co.uk
 | Norfolk NR13 3PN | F: +44 (0)1493 701 227 | W: www.struktur.co.uk

with compliments

**http://www.344design.com**

101 n. grand avenue, suite 7
tel/fax: 626.796.5148

pasadena, ca 91103
e-mail: three44@earthlink.net

three forty four design

DESIGN COMPANY
three forty four design

DESIGNER
Stefan G. Bucher

COUNTRY OF ORIGIN
USA

DESCRIPTION
Anticlockwise from top left:
Address label
Letterhead
Compliments slip
Sticker
Business card

three forty four design
Stefan G. Bucher

101 n. grand avenue, suite 7
tel/fax: 626.796.5148

pasadena, ca 91103
e-mail: three44@earthlink.net

three forty four design    101 n. grand avenue, suite 7    pasadena, ca 91103

Graphic Design

# vidal<span style="color:gray">eg</span>loesener

13, rue du Marché-aux-Herbes
L-1728 Luxembourg
Grand Duchy of Luxembourg

Telephone (352) 26 20 15 20
Facsimile (352) 26 20 15 21

**Silvano Vidale**
Associate

E-mail vidalegloesener@pt.lu

Graphic Design

13, rue du Marché-aux-Herbes
L-1728 Luxembourg
Grand Duchy of Luxembourg

Telephone (352) 26 20 15 20
Facsimile (352) 26 20 15 21

E-mail vidaleglosener@pt.lu

Vidale-Gloesener S.à.r.l.

Capital social 12.500 Euro
BLC 18074979
TVA 1999 2411 719
RC Luxembourg B 71656

DESIGN COMPANY
Vidale Gloesener

DESIGNER
Silvano Vidale and
Tom Gloesener

COUNTRY OF ORIGIN
Luxembourg

DESCRIPTION
Anticlockwise from top left:
Letterhead (reverse)
Business card (front and
reverse)
Letterhead (front)

vidaleegloesener

13, rue du Marché-aux-Herbes
L-1728 Luxembourg
Grand Duchy of Luxembourg

Telephone (352) 26 20 15 20
Facsimile (352) 26 20 15 21

**vidaleGloesener**

13, rue du Marché-aux-Herbes
L-1728 Luxembourg
Grand Duchy of Luxembourg

Telephone (352) 26 20 15 20
Facsimile (352) 26 20 15 21

E-mail vidalegloesener@pt.lu

With compliments

**vidaleGloesener**

**Graphic Design**

Facture

13, rue du Marché-aux-Herbes
L-1728 Luxembourg
Grand Duchy of Luxembourg

Telephone (352) 26 20 15 20
Facsimile (352) 26 20 15 21

E-mail vidalegloesener@pt.lu

Vidale-Gloesener S.a.r.l.

Capital social 12.500 Euro
IBLC 18074979
TVA 1999 2411 719
RC Luxembourg B 71858

Total à payer
Nos factures sont payables à 30 jours sans retenue d'escompte.
Banque Générale du Luxembourg  30-017927-16

vidal**eg**loesener

DESIGN COMPANY
Vidale Gloesener

DESIGNER
Silvano Vidale and
Tom Gloesener

COUNTRY OF ORIGIN
Luxembourg

DESCRIPTION
Anticlockwise from top left:
Address label
Compliments slip (front and
reverse)
Invoice

19

 the Design unit   City College Manchester   Wythenshawe Centre   Moor Road   Wythenshawe   Manchester   M23 9BQ

telephone: 0161 957 1516      facsimile: 0161 957 1501
www.citycol.com/tdu      e-mail: tdu@ccm.ac.uk

DESIGN COMPANY
tDu

DESIGNER
the Design unit, City College
Manchester

COUNTRY OF ORIGIN
UK

DESCRIPTION
Anticlockwise from top left:
Letterhead
Compliments slip
Business cards
Deskpad
Notepad

 the Design unit   City College Manchester   Wythenshawe Centre   Moor Road   Wythenshawe   Manchester   M23 9BQ

telephone: 0161 957 1516      facsimile: 0161 957 1501
www.citycol.com/tdu      e-mail: tdu@ccm.ac.uk

with **compliments**

**niall** M JERVEYS
head of design

the Design unit  City College Manchester
Wythenshawe Centre  Moor Road  Wythenshawe  Manchester  M23 9BQ
telephone: 0161 957 1508    facsimile: 0161 957 1501
www.citycol.com/tdu    e-mail: njerveys@ccm.ac.uk

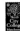

**sharon** WILLIAMS
senior graphic designer

the Design unit  City College Manchester
Wythenshawe Centre  Moor Road  Wythenshawe  Manchester  M23 9BQ
telephone: 0161 957 1516    facsimile: 0161 957 1501
www.citycol.com/tdu    e-mail: swilliams@ccm.ac.uk

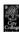

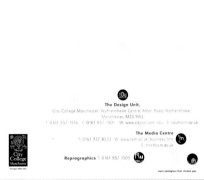

The Design Unit,
City College Manchester, Wythenshawe Centre, Moor Road, Wythenshawe,
Manchester, M23 9BQ
T: 0161 957 1516  F: 0161 957 1501  W: www.citycol.com/tdu  E: sdu@ccm.ac.uk

The Media Centre
T: 0161 957 8523  W: www.ccm.ac.uk  business.tmc
E: tmc@ccm.ac.uk

Reprographics  T: 0161 957 1503

**leigh** PILKINGTON
marketing advisor

the Design unit  City College Manchester
Wythenshawe Centre  Moor Road  Wythenshawe  Manchester  M23 9BQ
telephone: 0161 957 8519    facsimile: 0161 957 1501
www.citycol.com/tdu    e-mail: lpilkington@ccm.ac.uk

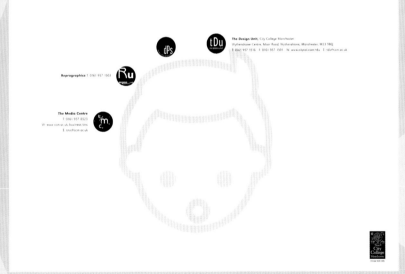

The Design Unit, City College Manchester
Wythenshawe Centre, Moor Road, Wythenshawe, Manchester, M23 9BQ
T: 0161 957 1516  F: 0161 957 1501  W: www.citycol.com/tdu  E: sdu@ccm.ac.uk

Reprographics  T: 0161 957 1503

The Media Centre
T: 0161 957 8523
W: www.ccm.ac.uk business.tmc
E: tmc@ccm.ac.uk

**shahrokh** NA'EL
web co-ordinator

the Design unit  City College Manchester
Wythenshawe Centre  Moor Road  Wythenshawe  Manchester  M23 9BQ
telephone: 0161 957 1516    facsimile: 0161 957 1501
www.citycol.com/tdu    e-mail: snael@ccm.ac.uk

**joanne** MACHIN
editor | proofreader

the Design unit  City College Manchester
Wythenshawe Centre  Moor Road  Wythenshawe  Manchester  M23 9BQ
telephone: 0161 957 1516    facsimile: 0161 957 1501
www.citycol.com/tdu    e-mail: jmachin@ccm.ac.uk

**adrian** LANCINI
senior graphic designer

the Design unit  City College Manchester
Wythenshawe Centre  Moor Road  Wythenshawe  Manchester  M23 9BQ
telephone: 0161 957 1516    facsimile: 0161 957 1501
www.citycol.com/tdu    e-mail: alancini@ccm.ac.uk

21

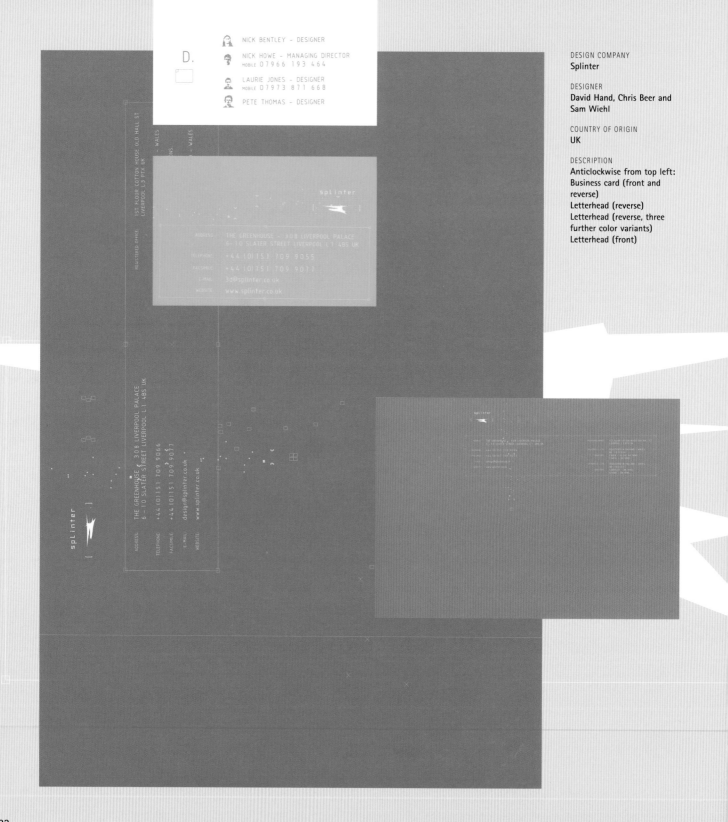

NICK BENTLEY - DESIGNER

NICK HOWE - MANAGING DIRECTOR
MOBILE 07966 193 464

LAURIE JONES - DESIGNER
MOBILE 07973 871 668

PETE THOMAS - DESIGNER

D.

DESIGN COMPANY
Splinter

DESIGNER
David Hand, Chris Beer and
Sam Wiehl

COUNTRY OF ORIGIN
UK

DESCRIPTION
Anticlockwise from top left:
Business card (front and
reverse)
Letterhead (reverse)
Letterhead (reverse, three
further color variants)
Letterhead (front)

splinter
[ ● ]

ADDRESS    THE GREENHOUSE – 308 LIVERPOOL PALACE
           6–10 SLATER STREET LIVERPOOL L1 4BS UK
TELEPHONE  +44 (0)151 709 9066
FACSIMILE  +44 (0)151 709 9077
E-MAIL     design@splinter.co.uk
WEBSITE    www.splinter.co.uk

REGISTERED OFFICE    1ST FLOOR COTTON HOUSE OLD HALL ST
                     LIVERPOOL L3 9TX UK

splinter
[ ● ]

ADDRESS    THE GREENHOUSE – 308 LIVERPOOL PALACE
           6–10 SLATER STREET LIVERPOOL L1 4BS UK
TELEPHONE  +44 (0)151 709 9055
FACSIMILE  +44 (0)151 709 9077
E-MAIL     3d@splinter.co.uk
WEBSITE    www.splinter.co.uk

SPLINTER

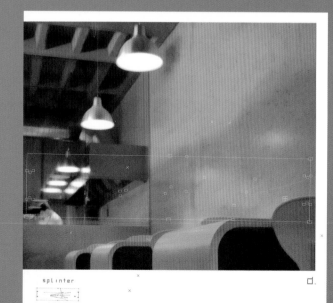

splinter

d.

c.

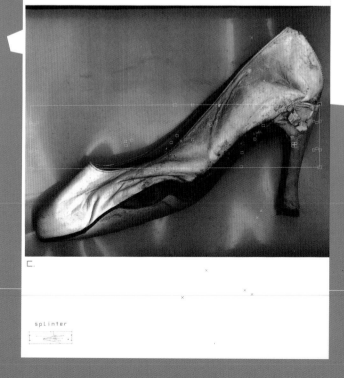

splinter

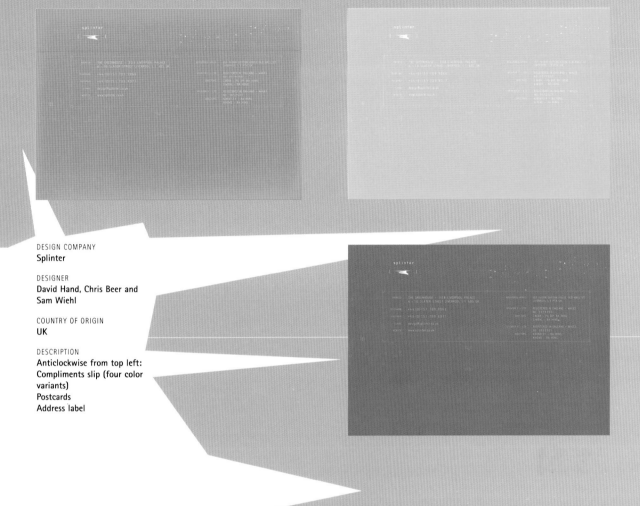

DESIGN COMPANY
Splinter

DESIGNER
David Hand, Chris Beer and
Sam Wiehl

COUNTRY OF ORIGIN
UK

DESCRIPTION
Anticlockwise from top left:
Compliments slip (four color
variants)
Postcards
Address label

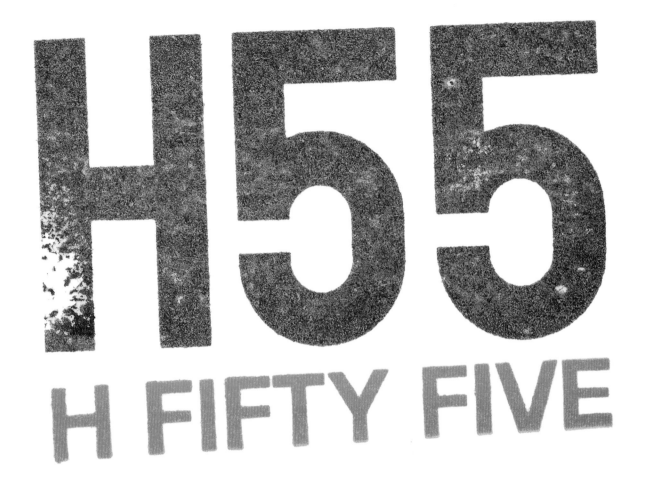

# H55
## H FIFTY FIVE

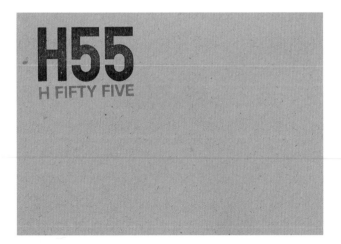

# H55
## H FIFTY FIVE

DESIGN COMPANY
H55

DESIGNER
Hanson Ho

COUNTRY OF ORIGIN
Singapore

DESCRIPTION
Anticlockwise from top left:
Envelope (front and reverse)
Letterhead

SPECIAL FEATURES
The company logotype is hand-stamped on to the items of stationery. The watermark effect on the letterhead is achieved by stamping on to the reverse of the sheet. Use of coarse-textured materials adds to the hand-produced effect.

H
5    5

H55

designing                H FIFTY FIVE            hanson ho
for a better future      tel + fax: 7337 585     pg: 9529 2623

H55
H FIFTY FIVE

28

hanson ho
design director

20 bideford road
03-06 wellington bldg
singapore 229921

pg : 9529 2623
tel :   7337 585
fax:   7343 171

**H55**

DESIGN COMPANY
**H55**

DESIGNER
**Hanson Ho**

COUNTRY OF ORIGIN
**Singapore**

DESCRIPTION
**Anticlockwise from top left:**
**Postcard (front and reverse)**
**Compliments slip**
**Envelope (front and reverse)**
**Business card (front and reverse)**

SPECIAL FEATURES
**See page 27.**

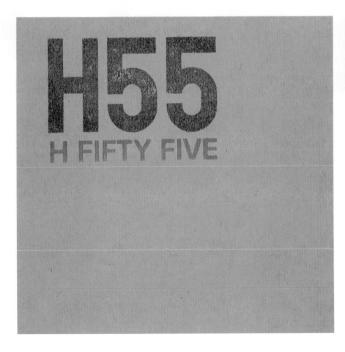

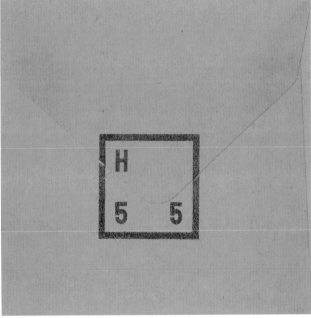

HOLLIS

{for your viewing pleasure}

344 7th avenue
san diego ca 92101
23 42 061
23 42 062

fold here

fold here

{that dog'll hunt}

operators are standing by

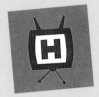

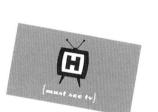

HOLLIS

{"H" marks the spot}

notes

operators are standing by

DESIGN COMPANY
**Hollis**

DESIGNER
**Heidi Sullivan and Don Hollis**

COUNTRY OF ORIGIN
**USA**

DESCRIPTION
**Anticlockwise from top left:**
**Letterhead (front and reverse)**
**Sticker**
**Note pad**
**Address label**
**Letter continuation sheet**

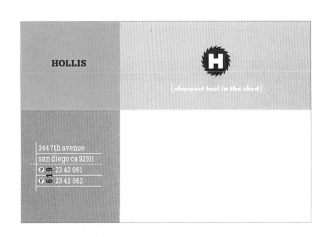

HOLLIS

{sharpest tool in the shed}

344 7th avenue
san diego ca 92101
619 23 42 061
619 23 42 062

31

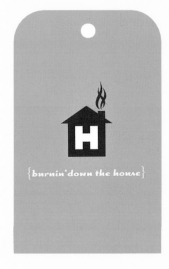

{burnin' down the house}

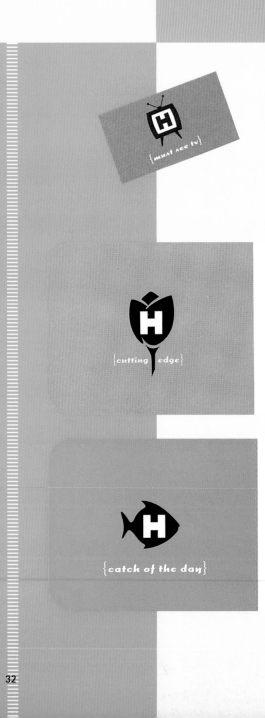

{what are tv}

{cutting edge}

{catch of the day}

**HOLLIS**

344 7th avenue
san diego ca 92101

P 619 234 2061
F 619 234 2062

**guusje bendeler**
green thumb

notes

razor sharp

guusjeb@hollisdesign.com

**HOLLIS**

344 7th avenue
san diego ca 92101

P 619 234 2061
F 619 234 2062

**don hollis**
chief angler

notes

all hooked up

donh@hollisdesign.com

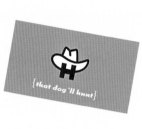

{that dog'll hunt}

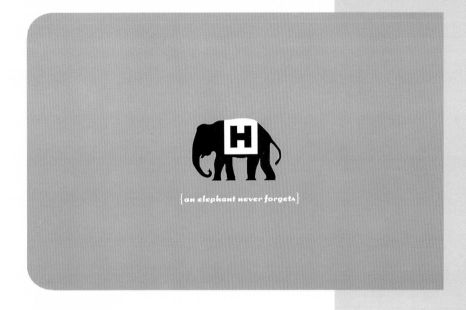

{an elephant never forgets}

**DESIGN COMPANY**
Hollis

**DESIGNER**
Heidi Sullivan and Don Hollis

**COUNTRY OF ORIGIN**
USA

**DESCRIPTION**
Anticlockwise from top left:
Sticker
Address tag
Business cards (front and reverse)
Postcard (front and reverse)

**SPECIAL FEATURES**
Each designer at the company
has created an individual icon,
title and tag line, which appears
on their business card.

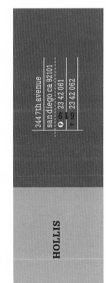

344 7th avenue
san diego ca 92101
23 42 061
23 42 062
619

HOLLIS

how do

swan brod

3682 gracin road
cincinnati, ohio 45226

phone: 513 - 924 - 1126
fax: 513 - 924 - 1125

stan brod

3662 grandin road
cincinnati, ohio 45226

E-mail: stan_brod@excite.com

phone: 513 - 924 -1126
fax: 513 - 924 -1125

E-mail: stan_brod@excite.com

DESIGN COMPANY
**Brod Design**

DESIGNER
**Brod Design**

COUNTRY OF ORIGIN
**USA**

DESCRIPTION
**Anticlockwise from top left:**
**Letterhead**
**Compliments slip**
**Business card**

stan brod

3662 grandin road
cincinnati, ohio 45226

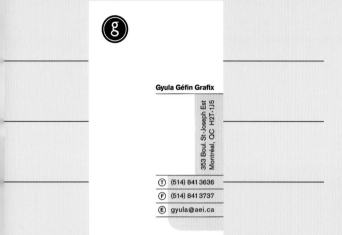

**Gyula Géfin Grafix**

353 Boul. St-Joseph Est
Montréal, QC H2T·1J5

(T) (514) 841 3636
(F) (514) 841 3737
(E) gyula@aei.ca

DESIGN COMPANY
**Gyula Géfin Grafix**

DESIGNER
**Gyula Géfin**

COUNTRY OF ORIGIN
**Canada**

DESCRIPTION
**Anticlockwise from top left:**
**Business card**
**Compliments slip**
**Letterhead**

**Gyula Géfin Grafix**

353 Boul. St-Joseph Est
Montréal, QC H2T·1J5

**Gyula Géfin Grafix**

353 Boul. St-Joseph Est
Montréal, QC H2T-1J5

T (514) 841 3636
F (514) 841 3737
E gyula@aei.ca

DESIGN COMPANY
**Brand New School**

DESIGNER
**Jonathan Notaro**

COUNTRY OF ORIGIN
**USA**

DESCRIPTION
Anticlockwise from top left:
Stickers
Postcard (front and reverse)
Business card (front and reverse)
Letterhead

SPECIAL FEATURES
The business cards are die cut to
reinforce the three-dimensional
effect of the cubic design.

brand
new
school

INFO@BRANDNEWSCHOOL.COM

1410 ABBOT KINNEY STE. 100
VENICE, CA 90291
310.460.0060
FX.460.0061

brand
new
school

BRANDNEWSCHOOL.COM

1410 ABBOT KINNEY STE. 100
VENICE, CA 90291
310.460.0060
FX.460.0061

brand
new
school

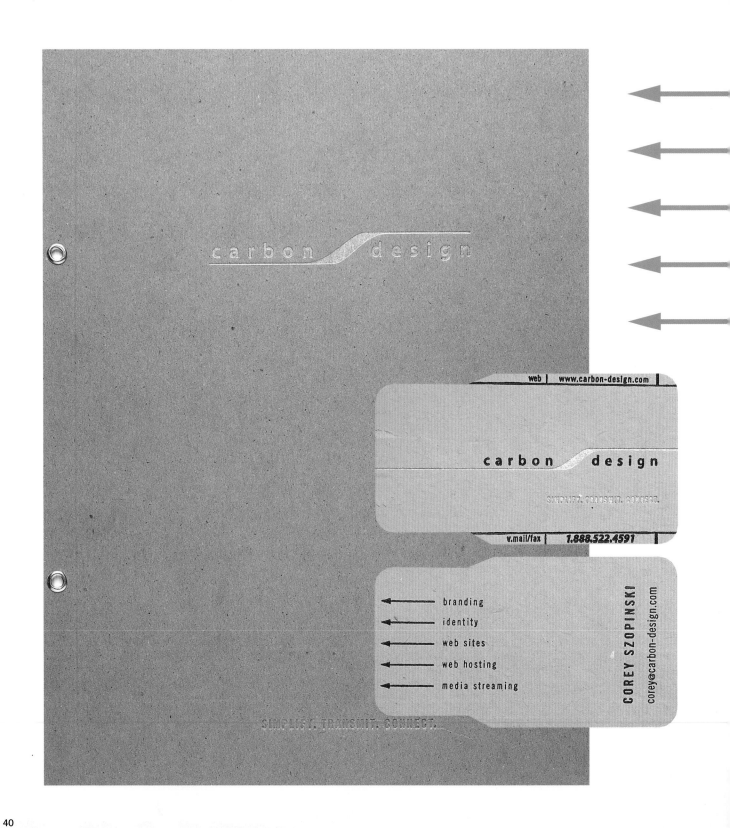

web | www.carbon-design.com

carbon design

SIMPLIFY. TRANSMIT. CONNECT.

v.mail/fax | 1.888.522.4591

branding
identity
web sites
web hosting
media streaming

COREY SZOPINSKI
corey@carbon-design.com

SIMPLIFY. TRANSMIT. CONNECT.

carbon design

DESIGN COMPANY
**Carbon Design**

DESIGNER
**Corey Szopinski**

COUNTRY OF ORIGIN
**USA**

DESCRIPTION
**Anticlockwise from top left:
Folder cover
Business card (front and
reverse)
Letterhead**

SPECIAL FEATURES
Areas of the folder and
business card are reverse
embossed. These areas are
printed with silver metallic
ink, which also appears on
the letterhead.

616 west wilson, madison, wi 53703          v.mail/fax: *1.888.522.4591*          www.carbon-design.com

DESIGN COMPANY
**signalgrau**

DESIGNER
**Dirk Uhlenbrock**

COUNTRY OF ORIGIN
**Germany**

DESCRIPTION
**Anticlockwise from top left:**
**Business card**
**Promotional card**
**Compliments slip**
**Letterhead**

SPECIAL FEATURES
**This stationery range uses grey**
**paper; screen printing produces**
**the white circles.**

**signalgrau** designbureau
dirk+knut uhlenbrock, ladenspelderstr. 42, d–45147 essen
+49.201.730511, +49.201.730521 fax, post@signalgrau.com

**signalgrau** designbureau
dirk+knut uhlenbrock, ladenspelderstr. 42, d–45147 essen
+49.201.730511, +49.201.730521 fax, post@signalgrau.com

signalgrau designbureau
dirk+knut uhlenbrock, ladenspelderstr. 42, d-45147 essen
+49.201.730511, +49.201.730521 fax, post@signalgrau.com

Susanne Saenger
Diplom Designerin
Ziegelstr. 3 / Halle 1
76185 Karlsruhe
Tel +49 721 / 9546956
Fax +49 721 / 9546957
susanne.saenger@t-online.de

duncan baird publishers
Roger Walton
London W1T 3QH

Karlsruhe, 18.2.2001

Dear Roger,

find enclosed material for your procjects
»personal stationary« and »self-promotional work«,

best regards,

Susanne Saenger

DESIGN COMPANY
**Susanne Saenger**

DESIGNER
**Susanne Saenger**

COUNTRY OF ORIGIN
**Germany**

DESCRIPTION
**Anticlockwise from top left:
Letterhead
Compliments cards (four
variants)
Business cards (four variants)**

WITH COMPLIMENTS

**Susanne Saenger** · Grafik-Design & Illustration · Ziegelstrasse 3 · D-76185 Karlsruhe
Tel +49.721.95 46 956 · Fax +49.721.95 46 957 · susanne.saenger@t-online.de

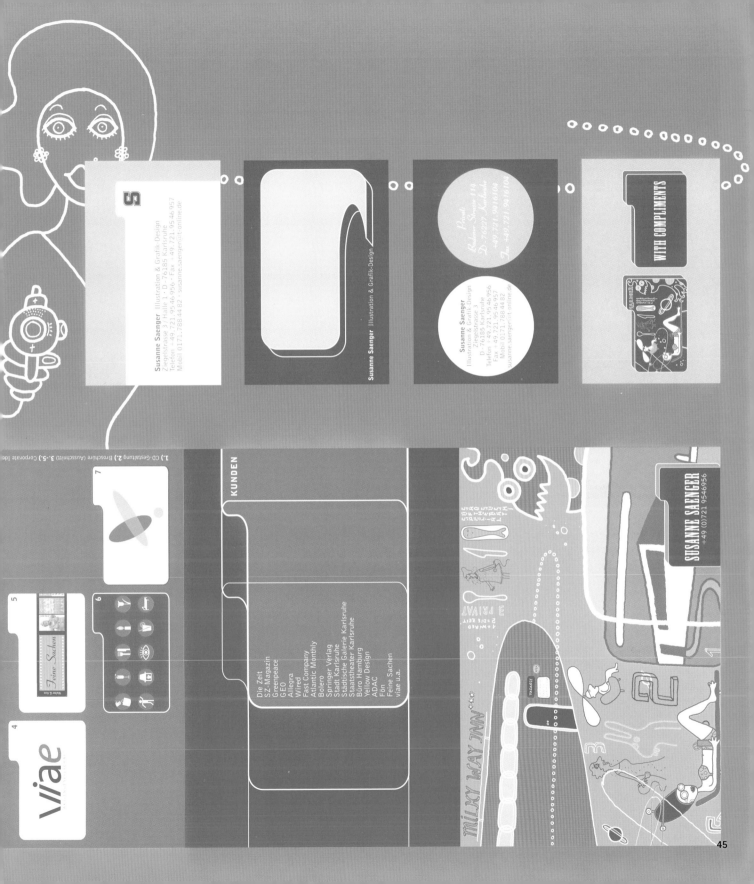

Susanne Saenger Illustration & Grafik Design
Ziegelstrasse 3 / Halle 1 · D-76185 Karlsruhe
Telefon +49.721.95.46.956 · Fax +49.721.95.46.957
Mobil 0171.788.44.82 · susanne.saenger@t-online.de

Susanne Saenger Illustration & Grafik-Design

Privat
Balinger Strasse 114
D-76227 Karlsruhe
+49.721.9416.104
Fax +49.721.9416.104

Susanne Saenger
Illustration & Grafik Design
Ziegelstrasse 3
D-76185 Karlsruhe
Telefon +49.721.95.46.956
Fax +49.721.95.46.957
Mobil 0171.788.44.82
susanne.saenger@t-online.de

WITH COMPLIMENTS

1.) CD-Gestaltung 2.) Broschure (Ausschnitt) 3.–5.) Corporate Ide...

KUNDEN

Die Zeit
SZ-Magazin
Greenpeace
GEO
Allegra
Wired
Fast Company
Atlantic Monthly
Bolero
Springer Verlag
Stadt Karlsruhe
Städtische Galerie Karlsruhe
Staatstheater Karlsruhe
Büro Hamburg
Yellow Design
ADAC
Fön
Feine Sachen
viae u.a.

SUSANNE SAENGER
+49 (0)721 9546956

MILKY WAY INN

MEMBER OF THE
TYPE DIRECTORS CLUB
NEW YORK

T +49 (0) 821 - 34 99 90 90
F +49 (0) 821 - 34 99 90 93
MOBIL 0170 - 80 15 439

ISDN +49 (0) 821 - 349 66 83
MAIL SALLACZ@LIQUIDNET.DE
WEB WWW.LIQUIDNET.DE

COORDINATES
E 10° 53' 30"
N 48° 22' 00"

LIQUID GBRMBH
BAHNHOFSTR. 10 RGB
D-86150 AUGSBURG

ILJA SALLACZ
DIPLOM DESIGNER

CREATIVDIRECTION

AGENTUR FÜR GESTALTUNG
LIQUD

COORDINATES
E 10° 53' 30"
N 48° 22' 00"

ISDN +49 (0) 821 - 349 66 83
MAIL INFO@LIQUIDNET.DE
WEB WWW.LIQUIDNET.DE

T +49 (0) 821 - 34 99 90 90
T +49 (0) 821 - 34 99 90 90
F +49 (0) 821 - 34 99 90 93

LIQUID GBRMBH
BAHNHOFSTR. 10 RGB
D-86150 AUGSBURG

AGENTUR FÜR GESTALTUNG
LIQUD

MEMBER OF THE
TYPE DIRECTORS CLUB
NEW YORK

DESIGN COMPANY
**Liquid**

DESIGNER
**Ilja Sallacz and Carina Orschulko**

COUNTRY OF ORIGIN
**Germany**

DESCRIPTION
**Anticlockwise from top left:**
**Business card**
**Letterhead**
**Compliments slip**
**Letter continuation sheet**

SPECIAL FEATURES
**The stationery items can be**
**customized using a choice of**
**labels (see page 48). The labels**
**are placed on embossed areas on**
**the stationery items.**

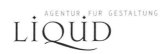

**liquidus 3** *(im Vers auch* liqu-; *m. comp.,* °*sup., adv.* -ē u. -ō; *s. u.;* liqueō) °**1.** flüssig, fließend; °**2.** klar *[aqua],* hell, durchsichtig, rein *[caelum];* **3.** / a) klar, rein; °**b)** heiter, ruhig; c) deutlich *[auspicium];* gewiß, bestimmt; °**4.** *subst.* -um, *i n* Flüssigkeit; Gewißheit; **5.** *adv.* -ō ohne Bedenken.

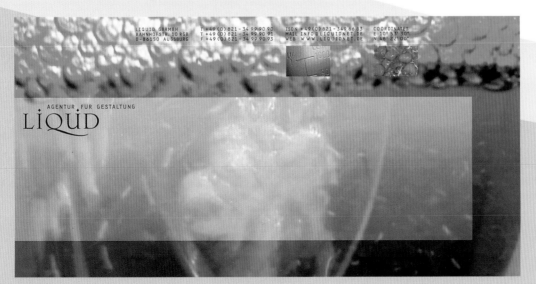

DESIGN COMPANY
**Liquid**

DESIGNER
**Ilja Sallacz and Carina
Orschulko**

COUNTRY OF ORIGIN
**Germany**

DESCRIPTION
**Anticlockwise from top left:
Stickers
Postcard
Bookmark (front and reverse)**

SPECIAL FEATURES
**See page 47.**

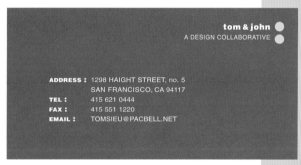

ADDRESS : 1298 HAIGHT STREET, no. 5
SAN FRANCISCO, CA 94117
TEL : 415 621 0444
FAX : 415 551 1220
EMAIL : TOMSIEU@PACBELL.NET

DESIGN COMPANY
Tom and John

DESIGNER
Tom and John

COUNTRY OF ORIGIN
USA

DESCRIPTION
Anticlockwise from top left:
Letterhead (reverse)
Letterhead (front)
Business cards (front), two
variants, and reverse

ADDRESS : 1298 HAIGHT STREET, no. 5
SAN FRANCISCO, CA 94117
TEL : 415 621 0444
FAX : 415 551 1220
EMAIL : TOMSIEU@PACBELL.NET
WEB : tom-john.com

ADDRESS : 1620 CASTRO STREET
SAN FRANCISCO, CA 94114
TEL : 415 641 5873
FAX : 415 824 1072
EMAIL : JOHN@IONIX.NET
WEB : tom-john.com

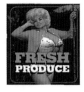
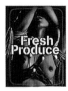
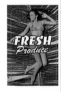
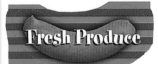
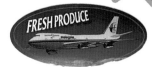

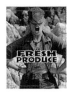
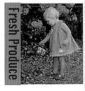

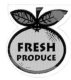
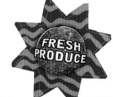
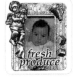

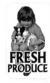
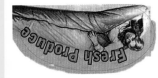

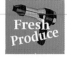
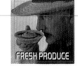

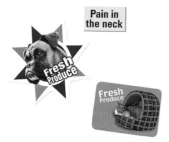

Fresh Produce  65 Leonard Street  London EC2A 4QS Tel 020 7256 1995  Fax 020 7256 1996  jules@fresh-produce.co.uk

DESIGN COMPANY
**Fresh Produce**

DESIGNER
**Julian Bigg**

COUNTRY OF ORIGIN
**UK**

DESCRIPTION
**Anticlockwise from top left:
Stickers
Letterhead
Compliments slip
Business card (front and reverse)**

SPECIAL FEATURES
Stickers are used to personalize
the otherwise plain letterhead
and compliments slip, making
each piece of correspondence
unique. The front of the business
card is a mosaic of tiny colored
stickers.

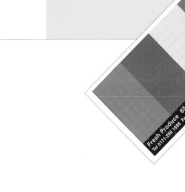

65 Leonard Street London EC2A 4QS United Kingdom  Tel 020 7256 1995  Fax 020 7256 1996  Email Jules@fresh-produce.co.uk

kirby "chip" wass

kirby "chip" wass

**wassco**
180 varick street
**8th floor**
**new** york city
10014          us.of.a
tel: 212-741-2550
fax: 212-741-7264

www.world.of.wassco.com

**wassco**
180 varick street
**8th floor**
**new** york city
10014          us.of.a
tel: 212-741-2550
fax: 212-741-7264

DESIGN COMPANY
**Wassco**

DESIGNER
**Neil Kopping**

COUNTRY OF ORIGIN
**USA**

DESCRIPTION
**Anticlockwise from
top left:
Letterhead (front)
Business card (front
and reverse)
Letterhead (reverse)**

DESIGN COMPANY
Wassco

DESIGNER
Neil Kopping

COUNTRY OF ORIGIN
USA

DESCRIPTION
Anticlockwise from top left:
Stickers
Address label
Envelope (reverse, open)
Envelope (reverse, closed)

SPECIAL FEATURES
The globular label is die cut
with circular holes. The
envelope is lined with pink
paper; die-cut holes
allow the color of the lining
or of the letter within (see
page 55) to show through.

**wassco**
180 varick street
8th floor
new york city
10014        us or a

**wassco**
180 varick street
**8th floor**
**new** york city
10014        us a

**KONTOUR**
3520 Glen Haven Houston, TX 77025
USA

phone 713.667.5928
email hagmann@kontour.com

www.kontour.com

DATE

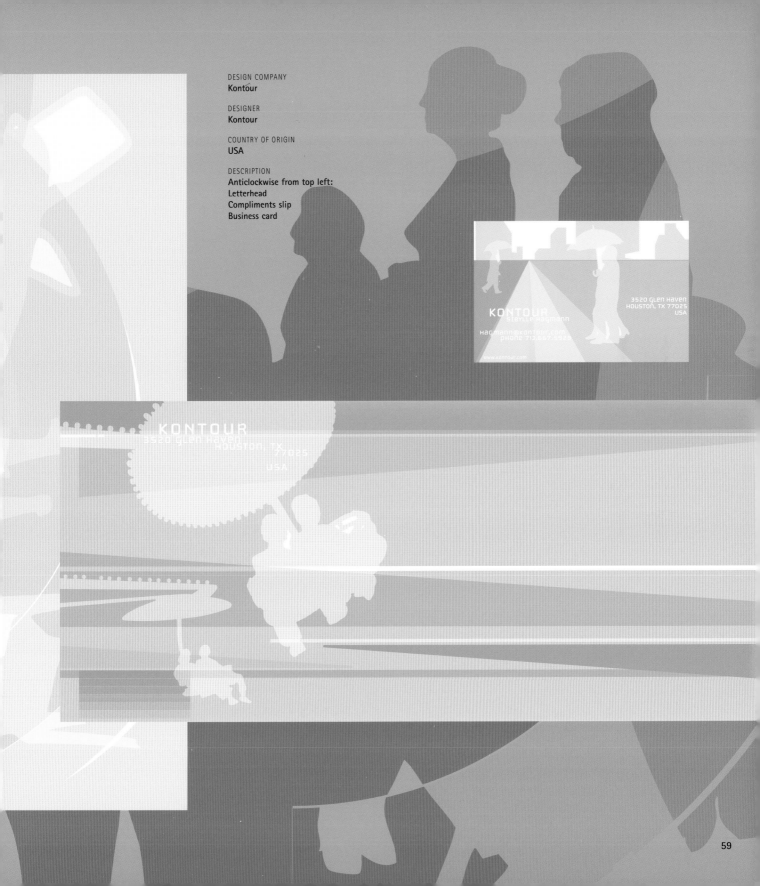

DESIGN COMPANY
**Kontour**

DESIGNER
**Kontour**

COUNTRY OF ORIGIN
**USA**

DESCRIPTION
**Anticlockwise from top left:
Letterhead
Compliments slip
Business card**

KONTOUR
Steylle Hagmann

3520 Glen Haven
Houston, TX 77025
USA

hagmann@kontour.com
Phone 713.667.5520

www.kontour.com

KONTOUR
3520 Glen Haven
Houston, TX 77025
USA

Mint
192 Clapham High St
London SW4 7UD

T (020) 7627 0066 F (020) 7627 0676
E-Mail scott@mint-design.co.uk
M (07703) 981 455

www.mint-design.co.uk

Scott Minshall

DESIGN COMPANY
**Mint**

DESIGNER
**Scott Minshall**

COUNTRY OF ORIGIN
**UK**

DESCRIPTION
**Anticlockwise from top left:
Business card (front and five
reverse variants)
Stickers**

MINT SIDE UP

www.
mint-
design.
co.uk

packed
minty
fresh
(020) 7627 0066

MINT

MINT
(020) 7627 0066

MINT
FRAGILE

MINT

www.
mint-
design.
co.uk

mint

MINT

mint

DESIGN COMPANY
**Mint**

DESIGNER
**Scott Minshall**

COUNTRY OF ORIGIN
**UK**

DESCRIPTION
**Anticlockwise from top left:
Letterhead (front)
Compliments slip (reverse)
Letterhead (reverse)
Compliments slip (front)**

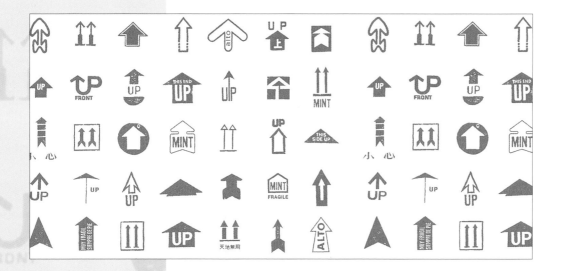

VAT Registration No 735 5498 03

**Mint**
192 Clapham High St
London SW4 7UD
T (020) 7627 0066 F (020) 7627 0676 M (07703) 981 455
E-Mail scott@mint-design.co.uk **www.mint-design.co.uk**

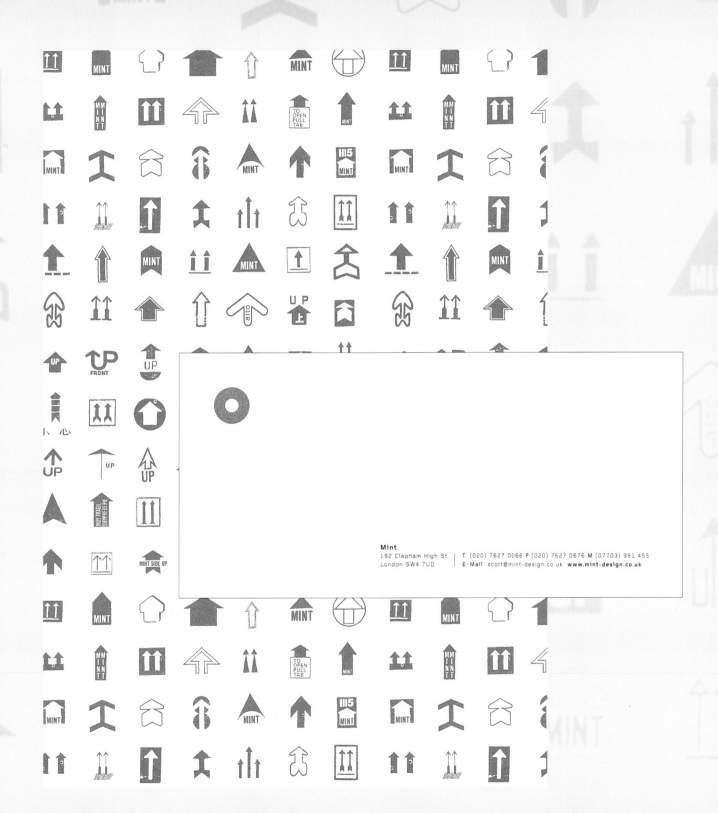

**Mint**
192 Clapham High St
London SW4 7UD
T (020) 7627 0066 F (020) 7627 0676 M (07703) 981 455
E-Mail scott@mint-design.co.uk www.mint-design.co.uk

Pdp Graphic Design

The Coach House
Rear of 'Moorlyn'
292 Tadcaster Road
York
YO24 1ET

VAT No. 599 2292 85

Telephone **01904 700673**
Facsimile 01904 700753
ISDN 01904 700826

e-mail info@pdpgraphicdesign.co.uk
www.pdpgraphicdesign.co.uk

Nicola North

Pdp Graphic Design

The Coach House
Rear of 'Moorlyn'
292 Tadcaster Road
York
YO24 1ET

Telephone 01904 700673
Facsimile 01904 700753
ISDN 01904 700826
e-mail nicola@pdpgraphicdesign.co.uk
www.pdpgraphicdesign.co.uk

DESIGN COMPANY
**Pdp Graphic Design**

DESIGNER
**Ashley McGovern and
Paul Cowen**

COUNTRY OF ORIGIN
**UK**

DESCRIPTION
**Anticlockwise from top left:
Letterhead
Business cards**

Pdp Graphic Design

| The Coach House | Telephone 01904 700673 |
| Rear of 'Moorlyn' | Facsimile 01904 700753 |
| 292 Tadcaster Road | ISDN 01904 700826 |
| York | e-mail ashley@pdpgraphicdesign.co.uk |
| YO24 1ET | www.pdpgraphicdesign.co.uk |

Ashley McGovern *Partner*

Paul Cowen *Partner*

Pdp Graphic Design

| The Coach House | Telephone 01904 700673 |
| Rear of 'Moorlyn' | Facsimile 01904 700753 |
| 292 Tadcaster Road | ISDN 01904 700826 |
| York | e-mail paul@pdpgraphicdesign.co.uk |
| YO24 1ET | www.pdpgraphicdesign.co.uk |

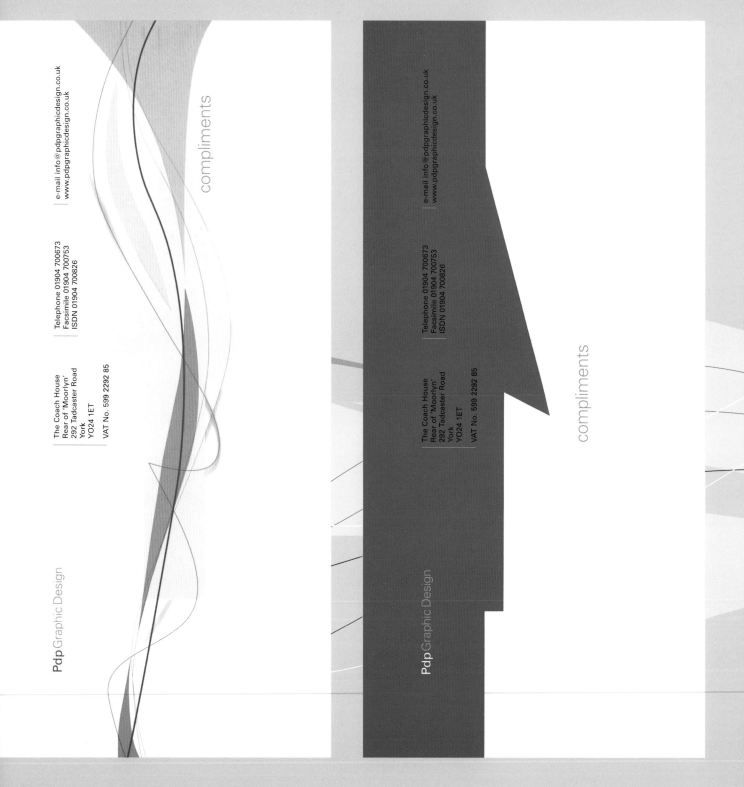

compliments

Telephone 01904 700673
Facsimile 01904 700753
ISDN 01904 700826

e-mail info@pdpgraphicdesign.co.uk
www.pdpgraphicdesign.co.uk

The Coach House
Rear of 'Moorlyn'
292 Tadcaster Road
York
YO24 1ET

VAT No. 599 2292 85

**Pdp** Graphic Design

compliments

Telephone 01904 700673
Facsimile 01904 700753
ISDN 01904 700826

e-mail info@pdpgraphicdesign.co.uk
www.pdpgraphicdesign.co.uk

The Coach House
Rear of 'Moorlyn'
292 Tadcaster Road
York
YO24 1ET

VAT No. 599 2292 85

**Pdp** Graphic Design

DESIGN COMPANY
**Pdp Graphic Design**

DESIGNER
**Ashley McGovern and
Paul Cowen**

COUNTRY OF ORIGIN
**UK**

DESCRIPTION
**Compliments slips**

Pdp Graphic Design

compliments

The Coach House
Rear of 'Moorlyn'
292 Tadcaster Road
York
YO24 1ET

VAT No. 599 2292 85

Telephone 01904 700673
Facsimile 01904 700753
ISDN 01904 700826

e-mail info@pdpgraphicdesign.co.uk
www.pdpgraphicdesign.co.uk

Z3 Limited
Graphic Design

Z3 Limited
Graphic Design

New Media
Creative Solutions

Z3 Limited, Loft 2, Broughton Works
27 George Street, Birmingham B3 1QG
T 0121 233 2545  F 0121 233 2544
E z3@btinternet.com  www.z3ltd.com
ISDN 0121 236 7914

Z3 Limited
Graphic Design
New Media
Creative Solutions

Z3 Limited
Loft 2
Broughton Works
27 George Street
Birmingham B3 1QG

T 0121 233 2545
F 0121 233 2544
ISDN 0121 236 7914

E z3@btinternet.com
www.z3ltd.com

Z3 Limited
Graphic Design
New Media
Creative Solutions

Z3 Limited
Loft 2
Broughton Works
27 George Street
Birmingham B3 1QG

T 0121 233 2545
F 0121 233 2544
ISDN 0121 236 7914

E z3@btinternet.com
www.z3ltd.com

DESIGN COMPANY
**Z3 Limited**

DESIGNER
**Richard Hunt and
Scott Raybould**

COUNTRY OF ORIGIN
**UK**

DESCRIPTION
**Anticlockwise from top left:
Letterhead (front)
Letterhead (reverse and front,
folded)
Compliments slip
Business cards**

SPECIAL FEATURES
**The company's contact details
appear on the reverse of the
letterhead. Unusual folding of
the letter places the graphic
below the contact details.**

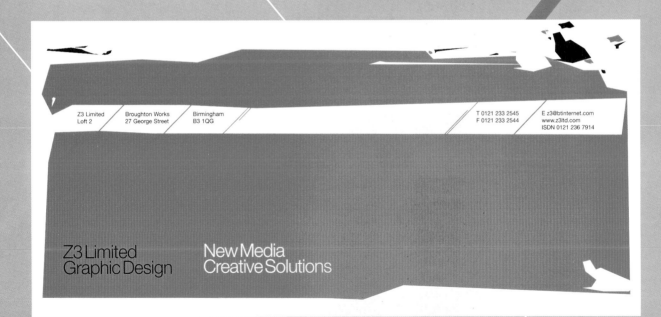

Z3 Limited
Loft 2

Broughton Works
27 George Street

Birmingham
B3 1QG

T 0121 233 2545
F 0121 233 2544

E z3@btinternet.com
www.z3ltd.com
ISDN 0121 236 7914

Z3 Limited
Graphic Design

New Media
Creative Solutions

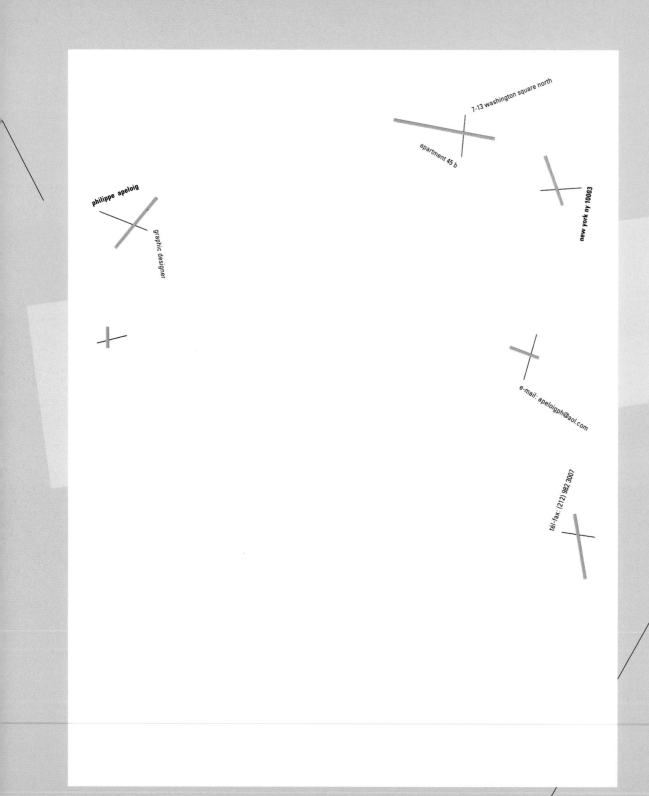

philippe apeloig

graphic designer

7-13 washington square north

apartment 45 b

new york ny 10003

e-mail: apeloigph@aol.com

tél-fax: (212) 982 3007

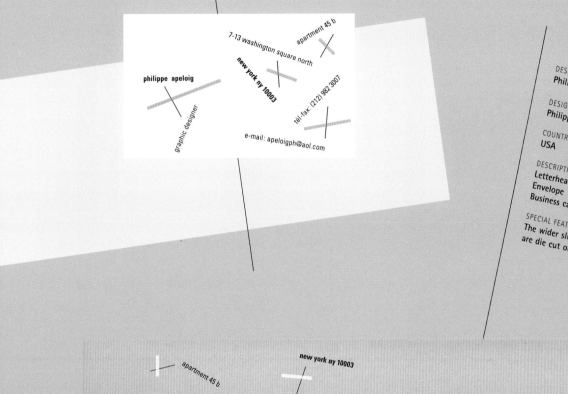

philippe apeloig

graphic designer

apartment 45 b

7-13 washington square north

new york ny 10003

tél-fax: (212) 982-3007

e-mail: apeloigph@aol.com

DESIGN COMPANY
**Philippe Apeloig Design**

DESIGNER
**Philippe Apeloig**

COUNTRY OF ORIGIN
**USA**

DESCRIPTION
**Letterhead
Envelope
Business card**

SPECIAL FEATURES
**The wider slits on the letterhead
are die cut out of the paper.**

philippe apeloig

graphic designer

apartment 45 b

new york ny 10003

7-13 washington square north

BERN: SANDRAINSTR. 3A, 3007 BERN  TEL. +41 (0)31 311 33 43  FAX. +41 (0)31 311 35 60
ZÜRICH  LETTENHOLZSTR. 3, 8038 ZÜRICH  TEL/FAX. +41 (0)1 481 05 77
WEB:  WWW.WALHALLA.CH  E-MAIL: INFO@WALHALLA.CH

DESIGN COMPANY
**Walhalla**

DESIGNER
**Walter Stahli, Ibrahim Zbat
and Marco Simonetti**

COUNTRY OF ORIGIN
**Switzerland**

DESCRIPTION
**Anticlockwise from top left:
Letterhead
Address label
Compliments slip
Notepad
Business card (front and
reverse)**

SPECIAL FEATURES
**The business card is screen
printed on sheet metal.**

NAME:

ADDRESS:

BERN: SANDRAINSTR. 3A, 3007 BERN  TEL. +41 (0)31 311 33 43  FAX. +41 (0)31 311 35 60
ZÜRICH: LETTENHOLZSTR. 3, 8038 ZÜRICH  TEL/FAX. +41 (0)1 481 05 77
WEB:  WWW.WALHALLA.CH  E-MAIL: INFO@WALHALLA.CH

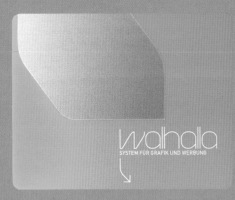

walhalla
SYSTEM FÜR GRAFIK UND WERBUNG

walhalla
SYSTEM FÜR GRAFIK UND WERBUNG

BERN:      SANDRAINSTR. 3A, 3007 BERN    TEL: +41 (0)31 311 33 43    FAX: +41 (0)31 311 35 60
ZÜRICH: LETTENHOLZSTR. 3, 8038 ZÜRICH    TEL/FAX: +41 (0)1 481 05 77
WEB:        WWW.WALHALLA.CH    E-MAIL: INFO@WALHALLA.CH

walhalla
SYSTEM FÜR GRAFIK UND WERBUNG
BERN:      SANDRAINSTR. 3A, 3007 BERN    TEL: +41 (0)31 311 33 43    FAX: +41 (0)31 311 35 60
ZÜRICH: LETTENHOLZSTR. 3, 8038 ZÜRICH    TEL/FAX: +41 (0)1 481 05 77
WEB:        WWW.WALHALLA.CH    E-MAIL: INFO@WALHALLA.CH

walhalla
SYSTEM FÜR GRAFIK UND WERBUNG

walhalla
SYSTEM FÜR GRAFIK UND WERBUNG

BERN     SANDRAINSTR. 3A, 3007 BERN   TEL. +41 (0)31 311 33 43   FAX +41 (0)31 311 35 60
ZÜRICH  LETTENHOLZSTR. 3, 6038 ZÜRICH   TEL./FAX +41 (0)1 481 05 77
WEB       WWW.WALHALLA.CH   E-MAIL INFO@WALHALLA.CH

BERN:    SANDRAINSTR. 3A, 3007 BERN   TEL. +41 (0)31 311 33 43  FAX. +41 (0)31 311 35 60
ZÜRICH:  LETTENHOLZSTR. 3, 8038 ZÜRICH  TEL/FAX. +41 (0)1 481 05 77
WEB:     WWW.WALHALLA.CH   E-MAIL. INFO@WALHALLA.CH

DESIGNER
**Robin Moore Oversby**

COUNTRY OF ORIGIN
**UK**

DESCRIPTION
**Anticlockwise from top left:**
**Business card (folded)**
**Business card (unfolded)**
**Compliments slip**
**Letterhead**

SPECIAL FEATURES
**A small flap on the business cards folds in to conceal the designer's initials (rm) and contact details.**

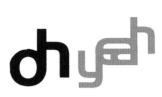

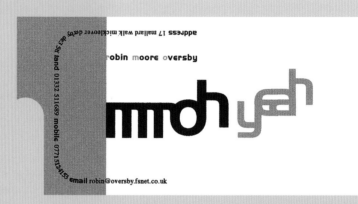

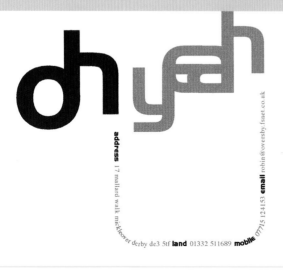

address 17 mallard walk mickleover derby de3 5tf **land** 01332 511689 **mobile** 07715 124153

email robin@oversby.fsnet.co.uk

robin moore oversby

[oncotyp
e]

D B P
Sixth Floor - Castle House
75-76 Wells Street
London W1T 3QH
*England*

**att: Roger Walton**

[ o n c o t y p e ] A
N i e l s  Hemmingsens gade  32A  DK - 1153 COPENHA
T :33 32 04 03  F:+45 33 32 0
w w
w. onco-
type.

otyp-

[onc

e]

DESIGN COMPANY
**Oncotype Aps**

DESIGNER
**Morten Schjøot and
Morten Westermann**

COUNTRY OF ORIGIN
**Denmark**

DESCRIPTION
**Anticlockwise from top left:
Label
Folder (front and reverse)
Letterhead**

[oncotyp
e]

DESIGN COMPANY
**Lateral**

DESIGNER
**Sam Collett**

COUNTRY OF ORIGIN
**UK**

DESCRIPTION
**Anticlockwise from top left:**
**Letterhead**
**Notepad**
**Address label**
**Business card**
**Overleaf: business cards**

SPECIAL FEATURES
**Each business card – even**
**that of the office dog –**
**carries a personalized**
**graphic and text identifier.**

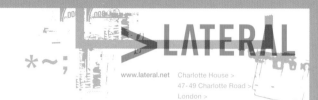

www.lateral.net   Charlotte House >
                  47-49 Charlotte Road >
                  London >
                  EC2A 3QT

e-mail   studio@lateral.net
tel   +44 [0]20 7613 4449
fax   +44 [0]20 7613 4645

Directors> Jon Bains, Simon Crabtree, David Hart, David Jones, Jill Magaard > Lateral Net Ltd. Registered in England  # 3401650 > address as above ;

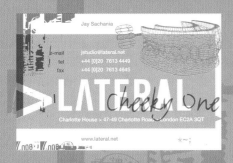

Jay Sachania

e-mail     jstudio@lateral.net
tel        +44 [0]20  7613 4449
fax        +44 [0]20  7613 4645

> LATERAL *Cheeky One*

Charlotte House > 47-49 Charlotte Road > London EC2A 3QT

www.lateral.net

> LATERAL

www.lateral.net

e-mail  studio@lateral.net    tel  +44 [0]20 7613 4449    fax  +44 [0]20 7613 4645

Lateral == Thinking

> LATERAL

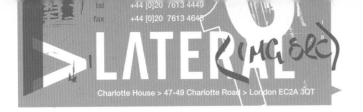

*~;

Charlotte House > 47-49 Charlotte Road > London EC2A 3QT

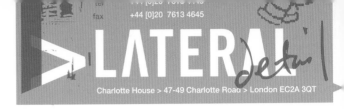

*~;

Charlotte House > 47-49 Charlotte Road > London EC2A 3QT

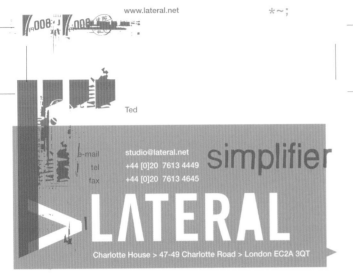

www.lateral.net

Ted

e-mail studio@lateral.net
tel +44 [0]20 7613 4449
fax +44 [0]20 7613 4645

simplifier

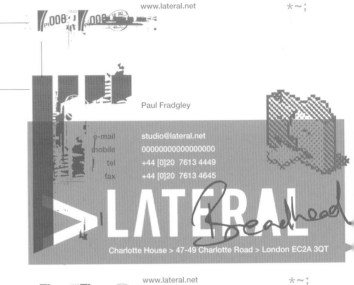

www.lateral.net

Paul Fradgley

e-mail studio@lateral.net
mobile 00000000000000000
tel +44 [0]20 7613 4449
fax +44 [0]20 7613 4645

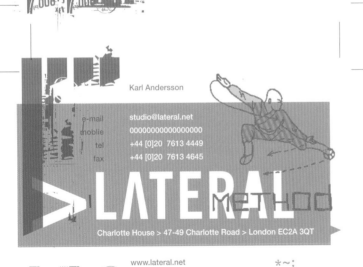

www.lateral.net

Karl Andersson

e-mail studio@lateral.net
mobile 00000000000000000
tel +44 [0]20 7613 4449
fax +44 [0]20 7613 4645

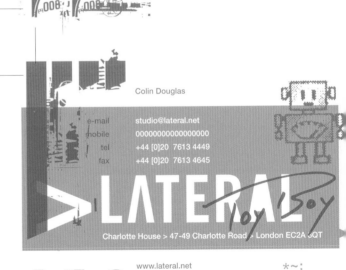

www.lateral.net

Colin Douglas

e-mail studio@lateral.net
mobile 00000000000000000
tel +44 [0]20 7613 4449
fax +44 [0]20 7613 4645

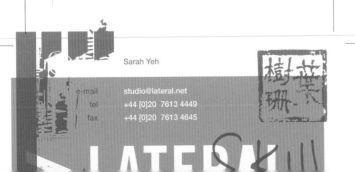

www.lateral.net

Sarah Yeh

e-mail studio@lateral.net
tel +44 [0]20 7613 4449
fax +44 [0]20 7613 4645

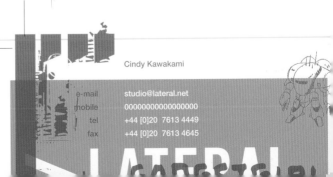

www.lateral.net

Cindy Kawakami

e-mail studio@lateral.net
mobile 00000000000000000
tel +44 [0]20 7613 4449
fax +44 [0]20 7613 4645

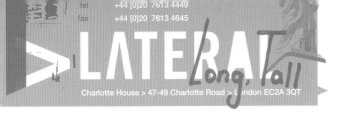

tel +44 [0]20 7613 4449
fax +44 [0]20 7613 4645

Charlotte House > 47-49 Charlotte Road > London EC2A 3QT

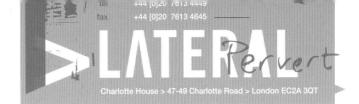

tel +44 [0]20 7613 4449
fax +44 [0]20 7613 4645

Charlotte House > 47-49 Charlotte Road > London EC2A 3QT

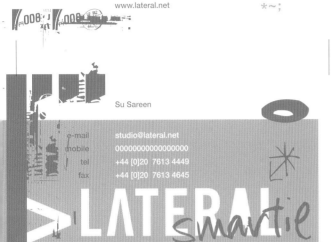

www.lateral.net

Su Sareen

e-mail studio@lateral.net
mobile 00000000000000000
tel +44 [0]20 7613 4449
fax +44 [0]20 7613 4645

Charlotte House > 47-49 Charlotte Road > London EC2A 3QT

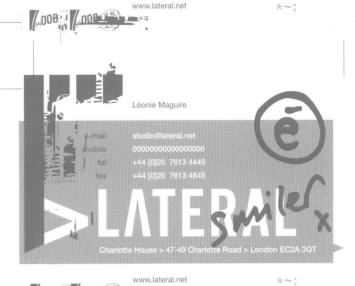

www.lateral.net

Léonie Maguire

e-mail studio@lateral.net
mobile 00000000000000000
tel +44 [0]20 7613 4449
fax +44 [0]20 7613 4645

Charlotte House > 47-49 Charlotte Road > London EC2A 3QT

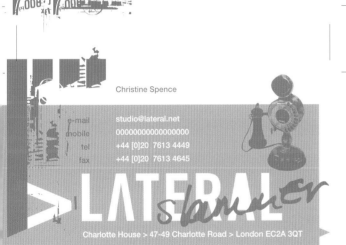

www.lateral.net

Christine Spence

e-mail studio@lateral.net
mobile 00000000000000000
tel +44 [0]20 7613 4449
fax +44 [0]20 7613 4645

Charlotte House > 47-49 Charlotte Road > London EC2A 3QT

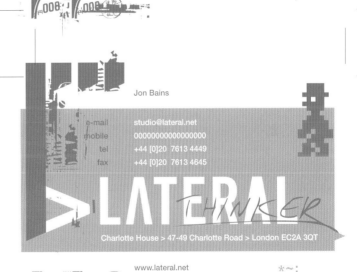

www.lateral.net

Jon Bains

e-mail studio@lateral.net
mobile 00000000000000000
tel +44 [0]20 7613 4449
fax +44 [0]20 7613 4645

Charlotte House > 47-49 Charlotte Road > London EC2A 3QT

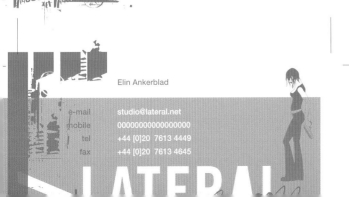

www.lateral.net

Elin Ankerblad

e-mail studio@lateral.net
mobile 00000000000000000
tel +44 [0]20 7613 4449
fax +44 [0]20 7613 4645

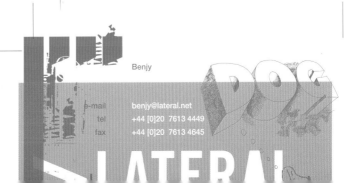

www.lateral.net

Benjy

e-mail benjy@lateral.net
tel +44 [0]20 7613 4449
fax +44 [0]20 7613 4645

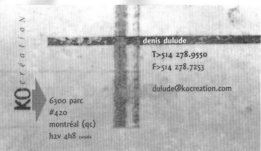

DESIGN COMPANY
**K.O. Création**

DESIGNER
**K.O. Création**

COUNTRY OF ORIGIN
**Canada**

DESCRIPTION
Anticlockwise from top left:
Business card (front and
reverse)
Postcard
Envelope
Letterhead (reverse only)

SPECIAL FEATURES
All items of stationery are
printed in black and
metallic green ink only.

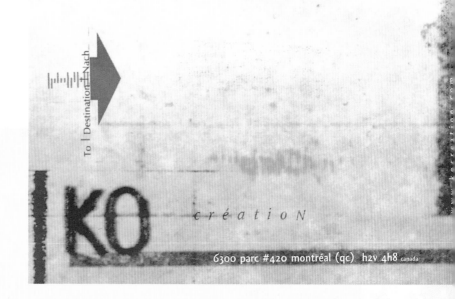

**KO** *création*

6300 parc
#420
montréal (qc)
h2v 4h8 canada

www.kocreation.com

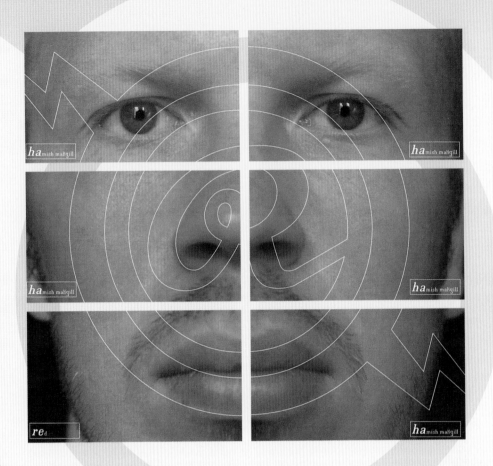

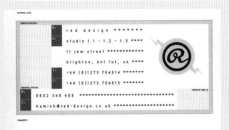

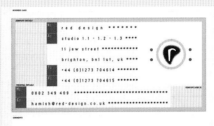

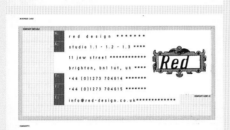

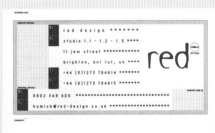

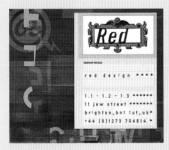

DESIGN COMPANY
**Red Design**

DESIGNER
**Red Design**

COUNTRY OF ORIGIN
**UK**

DESCRIPTION
**Anticlockwise from top left:**
**Business cards (reverse)**
**Compliments slip**
**Label**
**Business cards (front)**

SPECIAL FEATURES
**The reverse of each business**
**cards is printed with a section of**
**a photograph of the designer's**
**face. (Photographer: Harry**
**Dillon).**

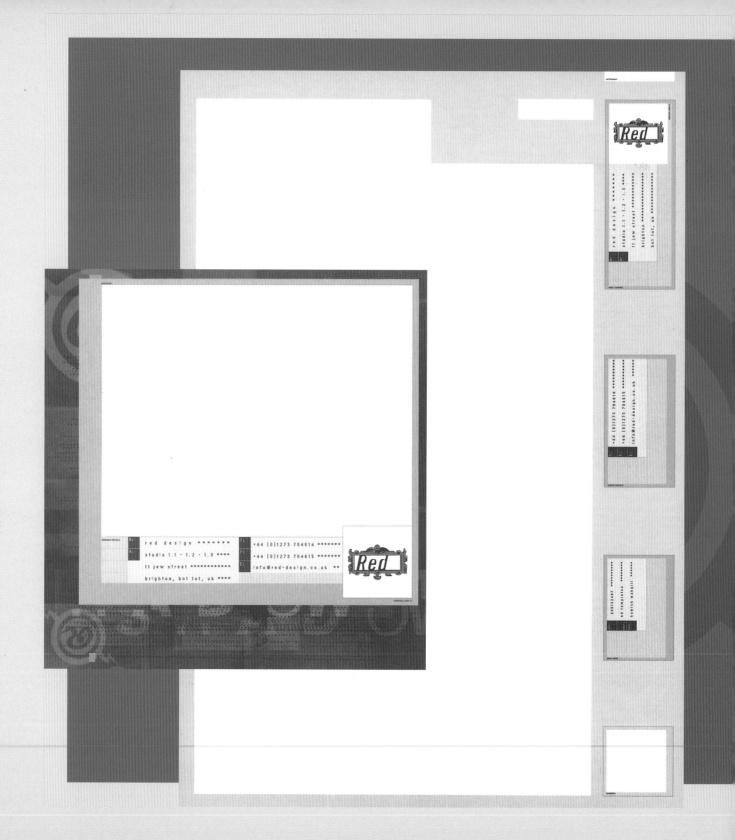

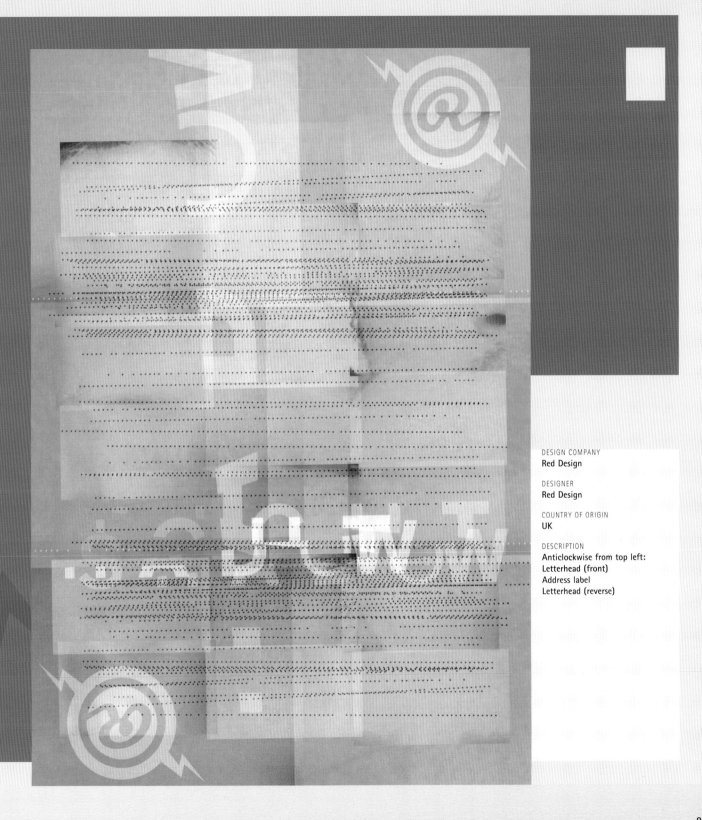

DESIGN COMPANY
**Red Design**

DESIGNER
**Red Design**

COUNTRY OF ORIGIN
**UK**

DESCRIPTION
**Anticlockwise from top left:**
**Letterhead (front)**
**Address label**
**Letterhead (reverse)**

DESIGNER
Daniel Sanchez

COUNTRY OF ORIGIN
UK

DESCRIPTION
Anticlockwise from top left:
Letterhead
Business card (front and reverse)
Compliments slip

SPECIAL FEATURES
The darker version of the
business card is printed on film.

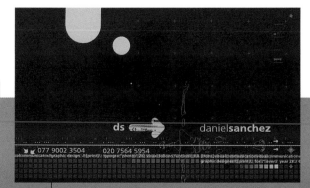

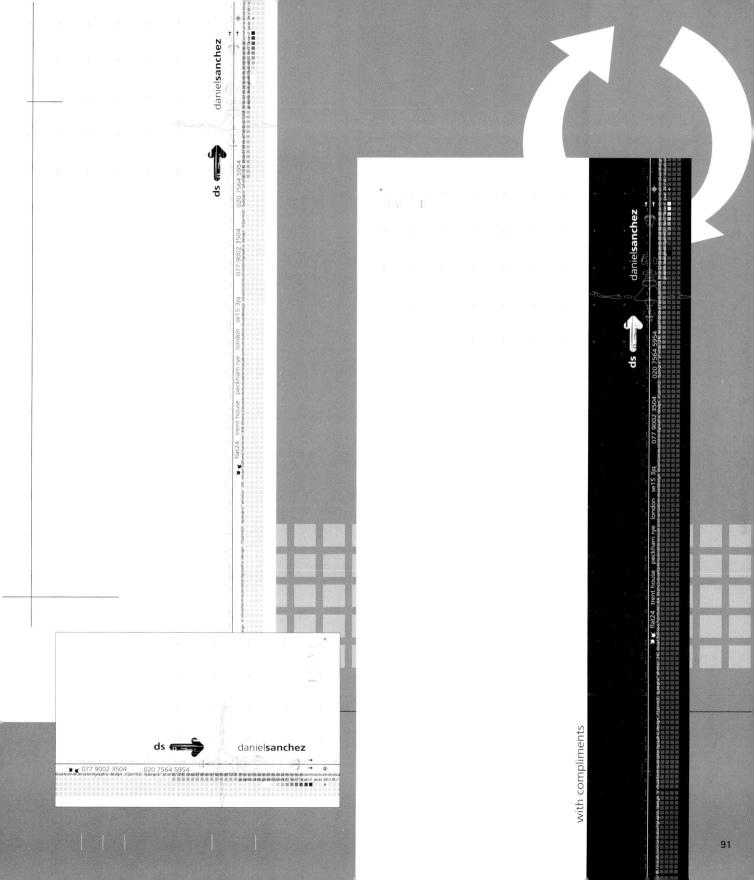

with compliments

Martijn Oostra, graphic designer

studio, Buyskade 39H, NL-1051 HT Amsterdam

The Netherlands

tel/fax +31 (0)20 / 688 96 46

e-mail studio@oostra.org

Roger Walton
Ducan Baird Publishers
Sixth Floor  Castle House
75-76 Wells Street
LONDON  W1P 3RE
ENGELAND

COMPANY STATIONERY                    AMSTERDAM / March 1st, 2001

DESIGN COMPANY
**Martijn Oostra Graphic Design**

DESIGNER
**Martijn Oostra**

COUNTRY OF ORIGIN
**Holland**

DESCRIPTION
Anticlockwise from top left:
Letterhead
Envelope
Fax template
Business card (front and reverse)

SPECIAL FEATURES
In a departure from convention,
the designer chooses to
emphasize the addressee's
details on the stationery.

Martijn Oostra, graphic designer

studio, Buyskade 39H,  NL-1051 HT  Amsterdam

The Netherlands

Roger Walton
Ducan Baird Publishers
Sixth Floor  Castle House
75-76 Wells Street
LONDON  W1P 3RE
ENGELAND

Martijn Oostra, graphic designer

studio, Buyskade 39H,  NL-1051 HT  Amsterdam

The Netherlands

tel/fax +31 (0)20 / 688 96 46

e-mail studio@oostra.org

**Roger Walton**

**Ducan Baird Publishers**

**Sixth Floor  Castle House**

**75-76 Wells Street**

**LONDON  W1P 3RE**

**ENGELAND**

# 0044 207 580 5692

COMPANY STATIONERY          AMSTERDAM / March 1st, 2001

Martijn Oostra,  grafisch ontwerper

studio: Buyskade 39H  1051 HT Amsterdam    020 / 688 96 46

gsm: 06 / 508 41 615

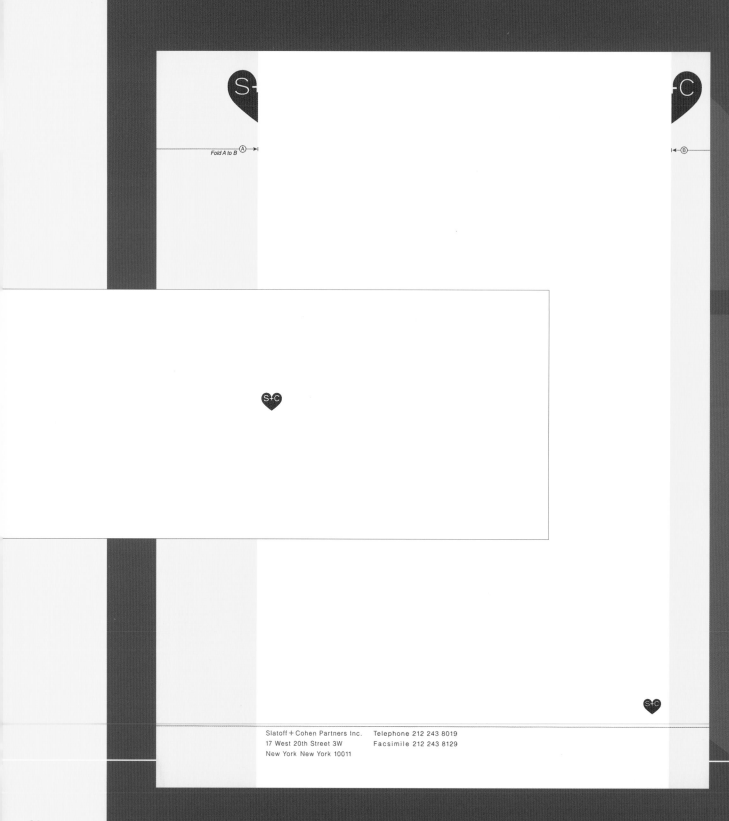

Fold A to B  (A)

(B)

S+C

S+C

Slatoff + Cohen Partners Inc.     Telephone 212 243 8019
17 West 20th Street 3W             Facsimile 212 243 8129
New York New York 10011

Slatoff + Cohen Partners Inc.
17 West 20th Street 3W
New York New York 10011

Telephone 212 243 8019
Facsimile 212 243 8129

David Slatoff

Slatoff + Cohen Partners Inc.
17 West 20th Street 3W
New York New York 10011

Telephone 212 243 8019
Facsimile 212 243 8129

Tamar Cohen

S+C

Slatoff + Cohen Partners Inc.    17 West 20th Street 3W
New York New York 10011

DESIGN COMPANY
**Slatoff and Cohen Partners**

DESIGNER
**Tamar Cohen, David Slatoff
and Alex Smith**

COUNTRY OF ORIGIN
**USA**

DESCRIPTION
**Anticlockwise from top left:
Letterhead
Envelope (front)
Address label
Business cards**

SPECIAL FEATURES
**The business card carries details
of both partners in the design
company. Perforations between
the two sections allow the
cards to be used separately.**

95

# Pentagram

Pentagram Design Limited
11 Needham Road
London W11 2RP
Telephone +44 (0)20 7229 3477
Fax +44 (0)20 7727 9932
email@pentagram.co.uk
www.pentagram.com

London
New York
San Francisco
Austin
Los Angeles

## Pentagram

Reg office
as address
Reg no 1399748
VAT Reg no
341 3877 62

Paula Scher
D J Stout
Daniel Weil
Lowell Williams

J Abbott Miller
John McConnell
Justus Oehler
Woody Pirtle
John Rushworth

April Greiman
Fernando Gutiérrez
David Hillman
Kit Hinrichs
Angus Hyland

Lorenzo Apicella
James Biber
Michael Bierut
Robert Brunner
Michael Gericke

## Pentagram

Pentagram Design Limited
11 Needham Road
London W11 2RP
Telephone +44 (0)20 7229 3477
Fax +44 (0)20 7727 9932
email@pentagram.co.uk
www.pentagram.com

## Pentagram

Pentagram Design Limited
11 Needham Road
London W11 2RP
Telephone +44 (0)20 7229 3477
Fax +44 (0)20 7727 9932
email@pentagram.co.uk

DESIGN COMPANY
Pentagram

DESIGNER
Pentagram

COUNTRY OF ORIGIN
UK

DESCRIPTION
Anticlockwise from top left: Letterhead, Compliments slip, Business card

**Peter Oehjne Design**
Königsteiner Straße 17
65929 Frankfurt/Main

Telefon 069. 30 03 67-59
Telefax 069. 30 03 67-60
www.oehjne-design.de
kontakt@oehjne-design.de

Stadt-Sparkasse Düsseldorf
Kontonummer 523 487 11
Bankleitzahl 300 501 10
USt-IdNr DE 196670075

Geschäftsführer P. Oehjne
Mitgliedschaften
Deutscher Designer Club e.V.

Peter Oehjne Design · Königsteiner Straße 17 · 65929 Frankfurt/Main

Kunstverlag Weingarten GmbH
Herr Muss-Prenzler
Lägelerstraße 31

88250 Weingarten

06.04.2000
**Buchprojekt ‚Ben Oyne - Werbefotografie'**

Sehr geehrter Herr Muss-Prenzler,

wie vereinbart erhalten Sie in der Anlage die von Ihnen für die Vertreter-
konferenz benötigten Unterlagen. Neben dem Buchdumy, einem neuen
Booklet und einem weiteren Exemplar der Selbstdarstellung haben wir
Ihnen noch einige Daten zu Ausstellungen, Auszeichnungen sowie
Veröffentlichungen zusammengestellt.

Mit besten Grüßen

Anlage     Buchdumy
           Booklet
           Selbstdarstellung
           Anhang

**Peter Oehjne Design**

**Peter Oehjne Design**
Königsteiner Straße 17
65929 Frankfurt/Main

Telefon 069. 30 03 67-59
Telefax 069. 30 03 67-60
www.oehjne-design.de
oehjne@oehjne-design.de

▶ Peter Oehjne
*Dipl.-Des.*

DESIGN COMPANY
**Eiche Oehjne Design**

DESIGNER
**Peter Oehjne**

COUNTRY OF ORIGIN
**Germany**

DESCRIPTION
**Anticlockwise from top left:**
**Letterhead**
**Business card**
**Postcard**

SPECIAL FEATURES
**The postcard has a folded**
**flap, allowing it to be stood**
**upright.**

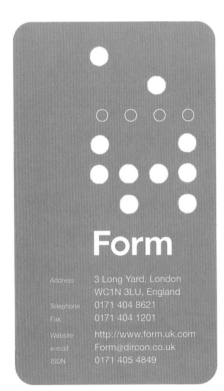

**Form**

| | |
|---|---|
| Address | 3 Long Yard, London WC1N 3LU, England |
| Telephone | 0171 404 8621 |
| Fax | 0171 404 1201 |
| Website | http://www.form.uk.com |
| e-mail | Form@dircon.co.uk |
| ISDN | 0171 405 4849 |

DESIGN COMPANY
**Form**

DESIGNER
**Paul West and Paula Benson**

COUNTRY OF ORIGIN
**UK**

DESCRIPTION
**Anticlockwise from top left:
Business card
Compliments slip
Letterhead**

SPECIAL FEATURES
**The business card is made from
die cut sheet metal, with text
etched into its surface. The
letterhead and compliments slip
use metallic silver ink and die
cut circles to echo this texture.**

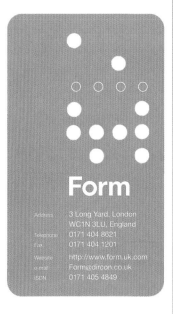

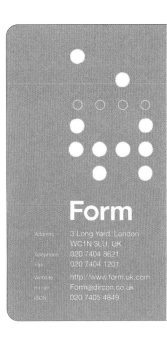

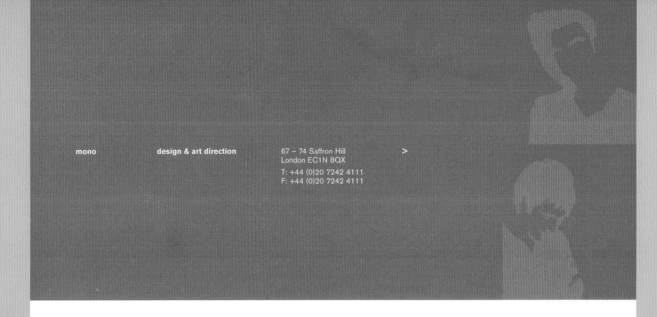

mono          design & art direction          67 – 74 Saffron Hill
                                               London EC1N 8QX

                                               T: +44 (0)20 7242 4111
                                               F: +44 (0)20 7242 4111

                                                              >

DESIGN COMPANY
mono

DESIGNER
mono

COUNTRY OF ORIGIN
UK

DESCRIPTION
Anticlockwise from top left:
Letterhead
Stickers
Address label
Insert label for disk casing

mono

design & art direction

# mono

67 – 74 Saffron Hill
London EC1N 8QX

T: +44 (0)20 7242 4111
F: +44 (0)20 7242 4111
www.monosite.co.uk

monosite.co.uk

mono          design & art direction          67 – 74 Saffron Hill
                                              London EC1N 8QX          >

T: +44 (0)20 7242 4111
F: +44 (0)20 7242 4111
www.monosite.co.uk

# mono

67 – 74 Saffron Hill
London EC1N 8QX

T: +44 (0)20 7242 4111
F: +44 (0)20 7242 4111
www.monosite.co.uk

DESIGN COMPANY
**Blatman Design**

DESIGNER
**Resa Blatman**

COUNTRY OF ORIGIN
**USA**

DESCRIPTION
**Anticlockwise from top left:**
**Business card**
**Address label on envelope**
**Letterhead**

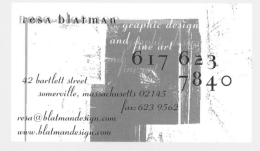

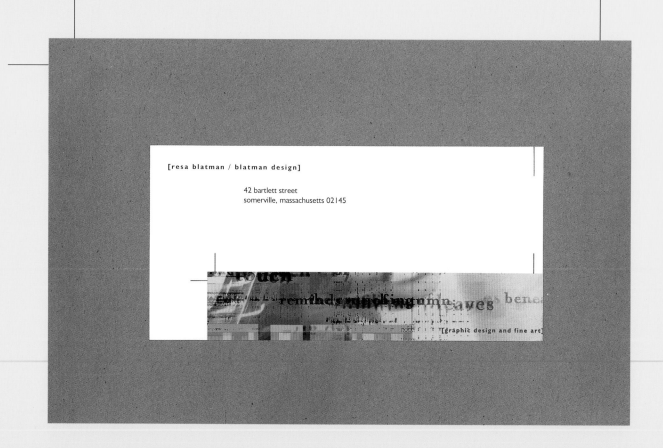

[resa blatman / blatman design]

42 bartlett street
somerville, massachusetts 02145

resa@blatmandesign.com

617 623 7840

[www.blatmandesign.com]

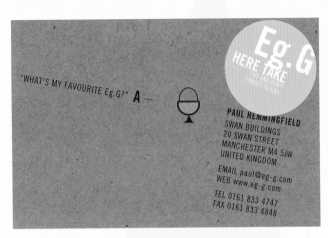

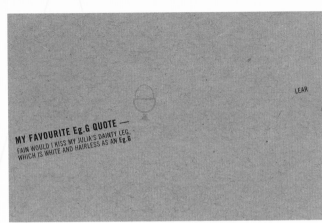

DESIGN COMPANY
*Eg.g*

DESIGNER
Dom Raban and Paul Hemingfield

COUNTRY OF ORIGIN
*UK*

DESCRIPTION
Anticlockwise from top left:
Business card (front and reverse, with self-adhesive label on front)
Letterhead (with self-adhesive label)
Moving card

SPECIAL FEATURES
The stationery is printed on earthy recycled stock. The bright yellow stickers are used to provide a strong visual counterpoint.

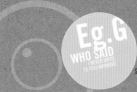

Eg.G
WHO SAID
I NEVER WRITE
TO YOU ANYMORE

SWAN BUILDINGS . 20 SWAN STREET . MANCHESTER . M4 5JW . TELEPHONE 0161 833 4747 . FAX 0161 833 4848
WEB www.eg-g.com EMAIL info@eg-g.com

STUDIO
SWAN BUILDINGS
20 SWAN STREET
MANCHESTER M4 5JW
TEL 0161 833 4747
FAX 0161 833 4848
ADMINISTRATION
ROCKFIELD HOUSE
23 BROCCO BANK
SHEFFIELD S11 8RQ
TEL 0114 266 7371
FAX 0114 266 7371

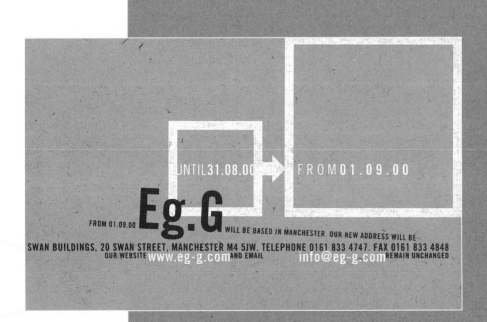

UNTIL 31.08.00 ➤ FROM 01.09.00

Eg.G
FROM 01.09.00 WILL BE BASED IN MANCHESTER. OUR NEW ADDRESS WILL BE
SWAN BUILDINGS, 20 SWAN STREET, MANCHESTER M4 5JW. TELEPHONE 0161 833 4747. FAX 0161 833 4848
OUR WEBSITE www.eg-g.com AND EMAIL info@eg-g.com REMAIN UNCHANGED

RUIZ ⊕ COMPANY    Teodoro Roviralta, 43
08022 Barcelona. Spain
T. 93 253 17 80   F. 93 253 17 81
www.ruizcompany.com

RUIZ ⊕ COMPANY Teodoro Roviralta, 43
08022 Barcelona. Spain. Tel. 93 253 17 80
Fax 93 253 17 81 www.ruizcompany.com

 TV

RUIZ ⊕ COMPANY TV    Teodoro Roviralta, 43
08022 Barcelona. Spain
T. 93 253 17 80   F. 93 253 17 81
www.ruizcompany.com

ANTON MOLINA
creacion@ruizcompany.com

MARINA COMPANY
marina@ruizcompany.com

RUIZ ⊕ COMPANY Teodoro Roviralta, 43
08022 Barcelona. Spain. Tel. 93 253 17 80
Fax 93 253 17 81 www.ruizcompany.com

RUIZ ⊕ COMPANY    Teodoro Roviralta, 43
08022 Barcelona. Spain
T. 93 253 17 80  F. 93 253 17 81
www.ruizcompany.com

DESIGN COMPANY
Ruiz Company

DESIGNER
Ruiz Company

COUNTRY OF ORIGIN
Spain

DESCRIPTION
Anticlockwise from top left:
Address labels
Business cards (front and
reverse)
Envelope

SPECIAL FEATURES
The strong graphic identity of
this design company is subtly
adapted for its TV production
division.

RUIZ ⊕ COMPANY    ART DIRECTION.
                  GRAPHIC DESIGN. TV.
                  PACKAGING. ETC.

Teodoro Roviralta, 43
08022 Barcelona. Spain
T. 93 253 17 80  F. 93 253 17 81
www.ruizcompany.com

RUIZ ⊕ COMPANY    ART DIRECTION.
                  GRAPHIC DESIGN. TV.
                  PACKAGING. ETC

Teodoro Roviralta, 43
08022 Barcelona. Spain
T. 93 253 17 80  F. 93 253 17 81
www.ruizcompany.com

DESIGN COMPANY
**Ruiz Company**

DESIGNER
**Ruiz Company**

COUNTRY OF ORIGIN
**Spain**

DESCRIPTION
**Anticlockwise from top left:
Letterhead
Letter within envelope
Letterhead (TV Division)**

SPECIAL FEATURES
**The envelope here is made of
translucent orange tracing paper,
allowing the addressee's details
on the letter within to show
through.**

DESIGN COMPANY
**Timespin**

DESIGNER
**Tino Schmidt**

COUNTRY OF ORIGIN
**Germany**

DESCRIPTION
**Anticlockwise from top left:**
**Business cards**
**Envelope**
**Letterhead**

**timespin**

info@timespin.de

tel. +49-3641-35970
fax. +49-3641-359711
www.timespin.de

timespin
digital communication gmbh

sophienstrasse 1
07743 jena
germany

**timespin**

**Tino Schmidt**
visual design

tel. +49-3641-35970
fax. +49-3641-359711
t.schmidt@timespin.de
www.timespin.de

timespin
digital communication gmbh

sophienstrasse 1
07743 jena
germany

*timespin*  digital communication gmbh | sophienstrasse 1 | 07743 jena | germany

**timespin**

timespin digital communication gmbh | sophienstrasse 1 | 07743 jena | germany

timespin
digital communication
gmbh

sophienstrasse 1
07743 jena | germany
tel. +49-3641-35 97 0
fax +49-3641-35 97 11
info@timespin.de
www.timespin.de

handelsregister |
amtsgericht gera
HRB 8192

geschäftsführerin |
sibylle straub

bankverbindung |
deutsche bank jena
Kto.-Nr. 3 921 900
BLZ 820 700 00

# Tau

Diseño para
la Comunicación

Inscrita en el Registro Mercantil de Madrid al Tomo 5.837 General. 4.897 de la Sección 3 del Libro de Sociedades. Folio 10, Hoja núm. 48.037. NIF A.28663425.

## Tau

Diseño para
la Comunicación

→ **Tau Diseño S.A.**
Felipe IV, 8. 2° izda.
28014 Madrid
Tel.: 91 369 32 34
Fax: 91 369 34 86
E-Mail: spain@taudesign.com

→ **Tau Diseño S.A.**
Felipe IV, 8. 2° izda.
28014 Madrid.
Tel.: 91 369 32 34
Fax: 91 369 34 86
E-Mail: spain@taudesign.com

DESIGN COMPANY
**Tau Design**

DESIGNER
**Emilo Gil**

COUNTRY OF ORIGIN
**Spain**

DESCRIPTION
**Anticlockwise from top left:**
**Letterhead**
**Envelope**
**Business card (front and reverse)**
**Folder cover**

Emilio Gil
**Director Creativo**

Tau Diseño para
la Comunicación

**Tau Diseño S.A.**
Felipe IV, 8. 2° izda.
28014 Madrid.
Tel.: 91 369 32 34
Fax: 91 369 34 86
→   E-Mail: spain@taudesign.com

Diseño para
la Comunicación

DESIGN COMPANY
**Young Guns Design**

DESIGNER
**Young Guns Design**

COUNTRY OF ORIGIN
**UK**

DESCRIPTION
**Anticlockwise from top left:
Business card (front and
reverse)
Compliments slip
Letterhead**

**young guns**
design

Robin Grime · Partner
tel · +44 (0)20 7734 0282
mobile · 07967 091 367
53 Beak St London W1R 3LF
e-mail · robin@younggunsdesign.com
www.younggunsdesign.com

With compliments

53 Beak St London W1R 3LF · tel · +44 (0)20 7734 0282 · www.younggunsdesign.com · e-mail · info@younggunsdesign.com

53 Beak St London W1R 3LF · tel · +44 (0)20 7734 0282 · www.youngunsdesign.com · e-mail · info@youngunsdesign.com

Neil Bowen
Designer
ZiP Design
07970 004 673
neil@zipdesign.co.uk

Unit 2A Queens Studio
121 Salusbury Road London NW6 6RG
T 020 7372 4474 F 020 7372 4484
ISDN 020 7328 2816
www.zipdesign.co.uk

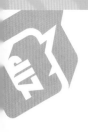

ISDN 020 7328 2816
E-mail info@zipdesign.co.uk

T 020 7372 4474
F 020 7372 4484

Unit 2A Queens Studio
121 Salusbury Road London NW6 6RG

ZiP Design
www.zipdesign.co.uk

ZiP Design Ltd. A New State Company - Registered in England No. 3186711 VAT No. 676 0140 45

Caroline Moorhouse
Designer
ZiP Design
07970 004 671
caroline@zipdesign.co.uk

Unit 2A Queens Studio
121 Salusbury Road London NW6 6RG
T 020 7372 4474 F 020 7372 4484
ISDN 020 7328 2816
www.zipdesign.co.uk

ZiP Design
www.zipdesign.co.uk

Unit 2A Queens Studio
121 Salusbury Road London NW6 6RG

T 020 7372 4474
F 020 7372 4484

ISDN 020 7328 2816
E-mail info@zipdesign.co.uk

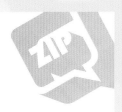

With Thanks

DESIGN COMPANY
**Zip Design**

DESIGNER
**Caroline Moorhouse, Neil
Bowen and Peter Chadwick**

COUNTRY OF ORIGIN
**UK**

DESCRIPTION
**Anticlockwise from top left:
Business card (front and
reverse)
Letterhead
Compliments slip (front and
reverse)
Business card (front and
reverse)**

DESIGN COMPANY
**Super Natural Design**

DESIGNER
**Hajdeja Ehline**

COUNTRY OF ORIGIN
**USA**

DESCRIPTION
**Anticlockwise from top left:**
**Stickers**
**Labels (two variants)**
**Business cards (three variants)**
**Letterhead**
**Address label**

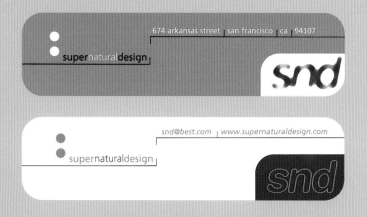

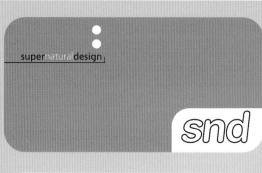

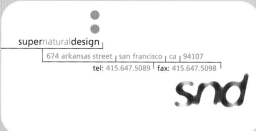

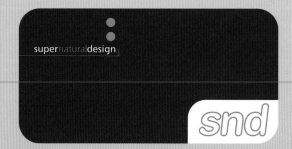

**super**natural**design**

674 arkansas street | san francisco | ca | 94107
tel: 415.647.5089 | fax: 415.647.5098

**snd**

**super**natural**design**

674 arkansas street | san francisco | ca | 94107
tel: 415.647.5089 | fax: 415.647.5098

**snd**

snd@best.com | www.supernaturaldesign.com

1  2  3  4  5  6  7  8  9  10  11  12  13  14  15  16  17  18  19  20  21  22  23  24  25  26  27  28  29  30  31

DESIGN COMPANY
**Yam**

DESIGNER
**Craig Yamey**

COUNTRY OF ORIGIN
**UK**

DESCRIPTION
**Anticlockwise from top left:**
**Letterhead**
**Compliments slip**
**Business card**

SPECIAL FEATURES
**The letterhead provides space to**
**type in the month of the year**
**adjacent to the days of the**
**month. The date is then circled**
**in orange.**

32 Crofton Road   London SE5 8NB     Pager 07654 667 254
Email craigyamey@hotmail.com        Tel-Fax 0207 207 6989

AGRAPHE

5 rue du Colonel Oudot 75012 PARIS - Téléphone (33) 01 43 40 85 85 . Télécopie (33) 01 43 40 85 55
SARL au capital de 50 000 Francs - RCS PARIS B 419 719 521 APE 744B - e-mail : agraphe@cybercable.fr · http://www.agraphe.com

AGRAPHE

5 rue du Colonel Oudot  75012 PARIS - Téléphone : (33) 01 43 40 85 85
Télécopie : (33) 01 43 40 85 55 - e-mail : agraphe@cybercable.fr

http://www.agraphe.com

thomas erhel

DESIGN COMPANY
**Agraphe**

DESIGNER
**Agraphe**

COUNTRY OF ORIGIN
**France**

DESCRIPTION
**Anticlockwise from top left:**
**Letterhead**
**Postcard**
**Business card (front and reverse)**

SPECIAL FEATURES
The company logo is foil blocked
on to a coated stock.

5 rue du Colonel Oudot 75012 PARIS - Téléphone (33) 01 43 40 85 85 - Télécopie (33) 01 43 40 85 55 - e-mail : agraphe@cybercable.fr

5 rue du Colonel Oudot 75012 PARIS - Téléphone (33) 01 43 40 85 85
Télécopie (33) 01 43 40 85 55 - e-mail : agraphe@cybercable.fr

DESIGN COMPANY
**Agraphe**

DESIGNER
**Agraphe**

COUNTRY OF ORIGIN
**France**

DESCRIPTION
**Anticlockwise from top left:**
**Self-adhesive label**
**Postcard (front and reverse)**
**Address label**

SPECIAL FEATURES
**The address label takes the form**
**of a thin strip.**

5 rue du Colonel Oudot 75012 PARIS - Téléphone (33) 01 43 40 85 85 - Télécopie (33) 01 43 40 85 55 - e-mail : agraphe@cybercable.fr

**AGRAPHE**

5 rue du Colonel Oudot 75012 PARIS - Téléphone (33) 01 43 40 85 85
Télécopie (33) 01 43 40 85 55 - e-mail : agraphe@cybercable.fr

design

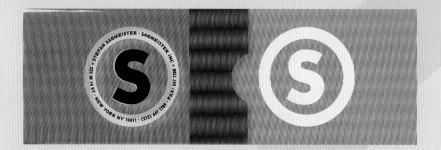

DESIGN COMPANY
**Sagmeister Inc**

DESIGNER
**Stefan Sagmeister**

COUNTRY OF ORIGIN
**USA**

DESCRIPTION
Anticlockwise from top left:
Business card in plastic sleeve
Business card part withdrawn
from sleeve
Letterhead folded and wrapped
by plastic band
Letterhead (front)

SPECIAL FEATURES
This stationery range uses the
Moiré effect to striking visual
effect. The business card is
printed with a pattern of narrow
rules; its translucent plastic sleeve
is printed similarly, resulting in a
shimmering visual illusion. This
trick is repeated with the plastic
band that is wrapped around the
folded letter.

STYLE = FART

SAGMEISTER INC.

SAGMEISTER INC.

NEW YORK

222 WEST 14th STREET  NEW YORK  NY 10011  US of A  TEL (212) 647 1789  FAX (212) 647 1788

DESIGN COMPANY
Reverb

DESIGNER
James W Moore, Somi Kim,
Lisa Myat and Susan Parr

COUNTRY OF ORIGIN
USA

DESCRIPTION
Anticlockwise from top left:
Business card
Envelope
Compliments cards
Letterhead

**ReVerb**

with compliments

**ReVerb**

with compliments

5514 Wilshire Boulevard  9th floor  Los Angeles  California  90036

T 323 954 4370     F 323 938 7632     www.reverbstudio.com

**ReVerb**

**ReVerb**

with compliments

5514 Wilshire Boulevard  9th floor  Los Angeles  California  90036

**ReVerb**

**ReVerb**

**INSECT**
1 - 5 Clerkenwell Road  London  EC1M 5PA
T 020 7253 0533  F 020 7253 0053
fly1@insect.co.uk  www.insect.co.uk

DESIGN COMPANY
Insect

DESIGNER
Paul Humphrey and Luke Davis

COUNTRY OF ORIGIN
UK

DESCRIPTION
Anticlockwise from top left:
Letterhead (front and reverse)

LETTER

DESIGN COMPANY
Insect

DESIGNER
Paul Humphrey and Luke Davis

COUNTRY OF ORIGIN
UK

DESCRIPTION
Anticlockwise from top left:
Address label
Compliments slip (front and
reverse)
Business card

SPECIAL FEATURES
The address label is printed on
transparent film. The solid white
panel is produced by screen
printing; the contact details and
graphic are overprinted in red.
The business card is printed on
semi-opaque plastic, with the
white panel screen printed on
the reverse side.

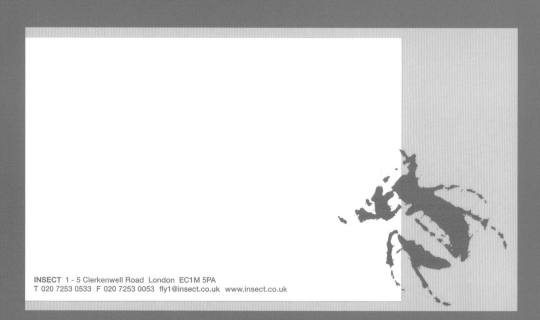

INSECT 1 - 5 Clerkenwell Road  London  EC1M 5PA
T 020 7253 0533  F 020 7253 0053  fly1@insect.co.uk  www.insect.co.uk

**INSECT**
1 - 5 Clerkenwell Road  London  EC1M 5PA
T 020 7253 0533  F 020 7253 0053
fly1@insect.co.uk  www.insect.co.uk

**INSECT**

1 - 5 Clerkenwell Road
London  EC1M 5PA
T 020 7253 0533  F 020 7253 0053
M 07977 682 027  ollie@insect.co.uk
www.insect.co.uk

OLLIE BLAND

WITH COMPLIMENTS

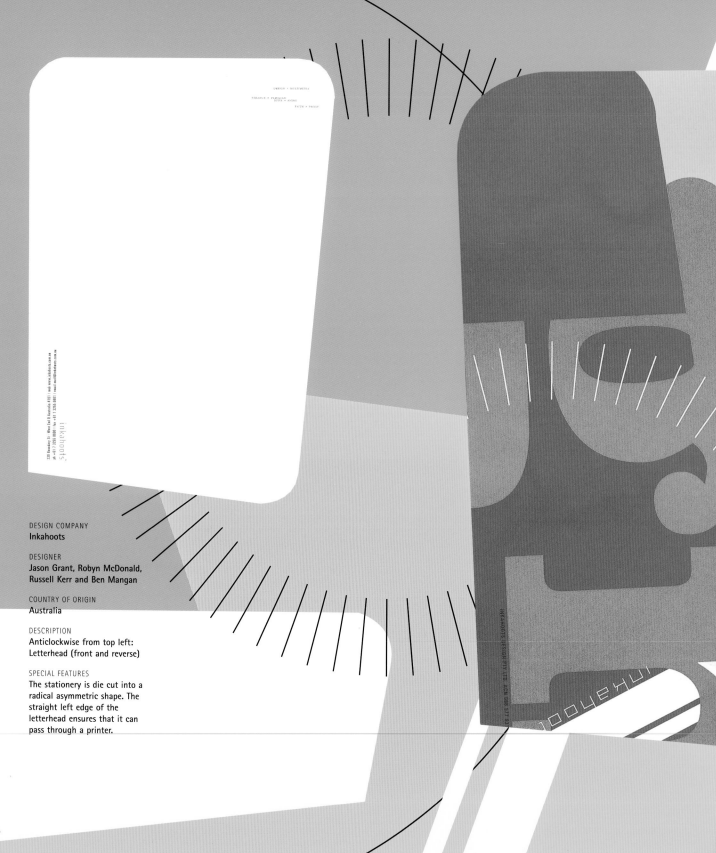

DESIGN COMPANY
Inkahoots

DESIGNER
Jason Grant, Robyn McDonald,
Russell Kerr and Ben Mangan

COUNTRY OF ORIGIN
Australia

DESCRIPTION
Anticlockwise from top left:
Letterhead (front and reverse)

SPECIAL FEATURES
The stationery is die cut into a
radical asymmetric shape. The
straight left edge of the
letterhead ensures that it can
pass through a printer.

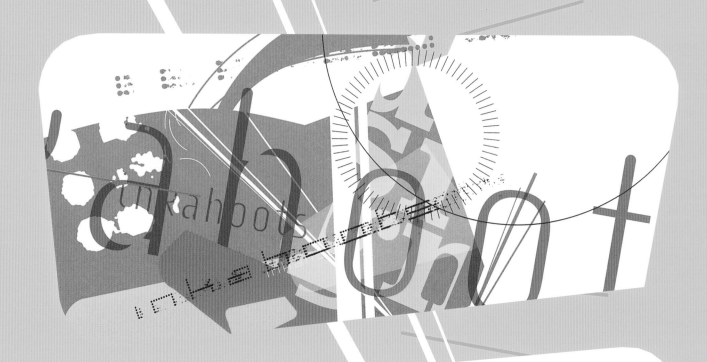

DESIGN + MULTIMEDIA

PUBLIC × PRIVATE
PRESENCE × ABSENCE

ROCK × ROLL

inkahoots™

239 Boundary St | West End Q Australia 4101 | web www.inkahoots.com.au
ph +61 7 3255 0800 | fax +61 7 3255 0801 | email mail@inkahoots.com.au

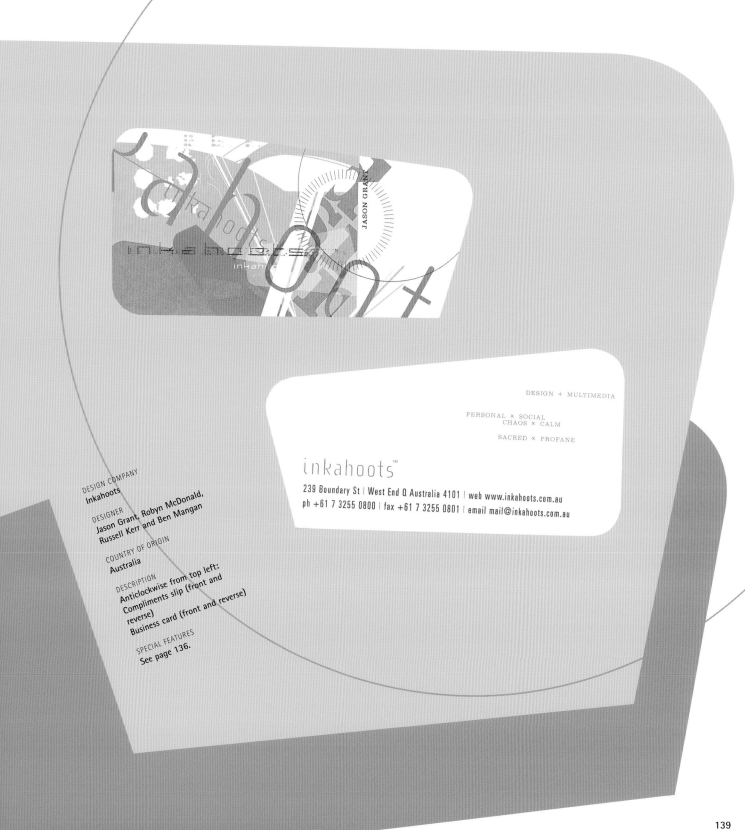

DESIGN + MULTIMEDIA

PERSONAL × SOCIAL
CHAOS × CALM

SACRED × PROFANE

inkahoots™

239 Boundary St | West End Q Australia 4101 | web www.inkahoots.com.au
ph +61 7 3255 0800 | fax +61 7 3255 0801 | email mail@inkahoots.com.au

DESIGN COMPANY
**Inkahoots**

DESIGNER
**Jason Grant, Robyn McDonald,
Russell Kerr and Ben Mangan**

COUNTRY OF ORIGIN
**Australia**

DESCRIPTION
**Anticlockwise from top left:
Compliments slip (front and
reverse)
Business card (front and reverse)**

SPECIAL FEATURES
**See page 136.**

# POSTSCRIPT

The United States Postal Sevice delivers more than 200 billion pieces of mail each year

The first woman to appear on a stamp was Queen Victoria in the United Kingdom who was pictured on the 'Penny Black'

Austria was the first country to use postcards

15,000 flights depart every day from the United States, carrying mail around the world

More than 100 cosmonauts used the post office on board the Russian space station Mir

Mail is still collected from and delivered to the bottom of the Grand Canyon by mule

Personal letters make up only 5%
of the mail delivered by the
United States Postal Sevice

The earliest known item of post
is an Egyptian clay letter dated
from around 2000BCE

The first official Royal Mail office
was opened in England in 1516

Great Britain was the first country
to issue postage stamps.
Brazil was the second

In 1693, letters were held in front of
a candle to determine postage rates.
The less light that shone through,
the higher the rate

The United States Postal Sevice
collects mail from more than
312,000 street mail collection boxes

# INDEX

Julian Morey

Studio **116**

**31** Clerkenwell Close

London **EC1R 0AT**

**0171**

Telephone **336 8970**

**0171**

Facsimile **490 2718**

DESIGN COMPANY
**Julian Morey Studio**

DESIGNER
**Julian Morey**

COUNTRY OF ORIGIN
**UK**

DESCRIPTION
**Letterhead**